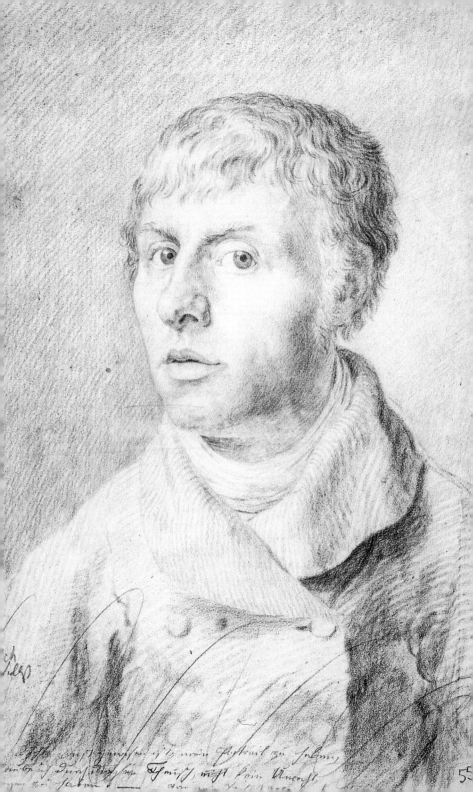

ch
1810

55

ArtBook
Friedrich

DORLING KINDERSLEY
London • New York • Sydney • Moscow
www.dk.com

Contents

How to use this book

This series presents both the life and works of each artist within the cultural, social, and political context of their time. To make the books easy to consult, they are divided into three areas which are identifiable by side bands: yellow for the pages devoted to the life and works of the artist, light blue for the historical and cultural background, and pink for the analysis of major works. Each spread focuses on a specific theme, with an introductory text and several annotated illustrations. The index section is also illustrated and gives background information on key figures and the location of the artist's works.

■ Page 2: Friedrich, *Self-portrait*, 1800, Statens Museum for Kunst, Copenhagen.

1774–1800

The early years

1801–1807

His career begins

Index

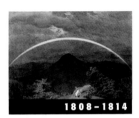

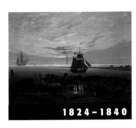

1808-1814

1815-1823

1824-1840

Inner landscapes

Maturity

Final works

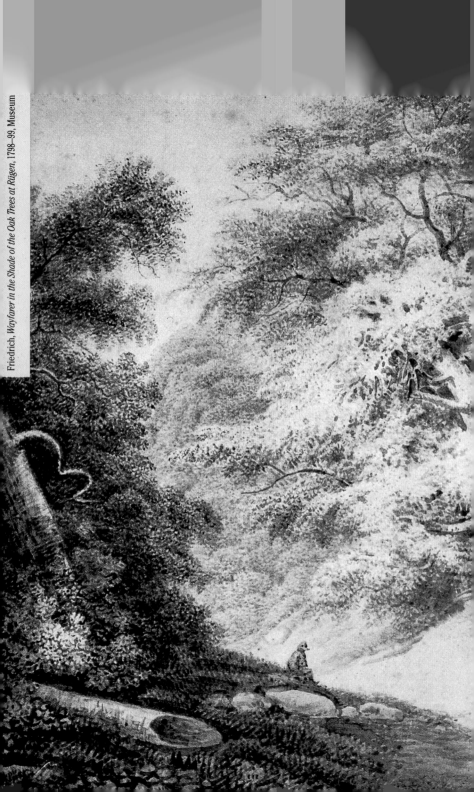

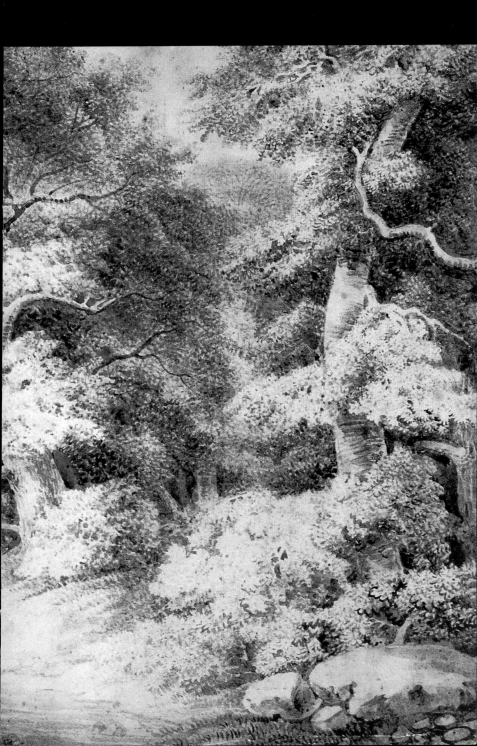

Childhood

Set in a small bay along the German Baltic coast lies Greifswald, a town in the region of Pomerania. A thriving and wealthy port during the Middle Ages, Greifswald fell to Sweden in the 18th century. It was here, on September 5, 1774, that Caspar David Friedrich was born, the sixth of ten children of a soap- and candle-maker, Adolph Gottlieb Friedrich, and his wife Sophie Dorothea Bechly, both from Neubrandenburg. The Friedrich family lived in a large house at Number 28 Langen Gasse. A shy and taciturn child, Friedrich experienced family tragedy at a young age: his mother died when he was only seven years old and, later, one of his brothers drowned. The strict education he received from his father, governed by the most rigid Protestant principles, and the teachings he gleaned from the religious writings of the theologian Gotthard Ludwig Kosegarten had a profound influence on the future artist, on his vision of the world, and on his relationship with nature. It was his art teacher at the University of Greifswald, Johann Gottfried Quistorp, who directed him towards Pietist and religious literature. Under his direction, Friedrich made his first artistic studies in 1790, copying paintings and views from Quistorp's own collection and producing a number of life drawings.

■ The main body of the church of St Nicholas, towering high above the many-colored houses of Greifswald, is clearly Gothic in style, with its ogival windows and red brick so typical of northern German Gothic architecture. The dome, not visible in the picture, was added a few years later in the baroque style.

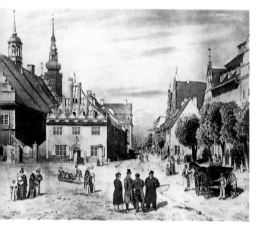

■ Left: Friedrich, *The Market Square, Greifswald*, 1818, Museum der Stadt, Greifswald. Only in 1815 would Friedrich's native town once again be part of the Prussian kingdom, after almost two hundred years of Swedish rule.

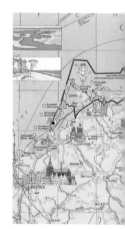

■ Friedrich's Pomerania, with his native Greifswald and the island of Rügen.

■ Friedrich, *Portrait of the Artist's Father Adolph Gottlieb Friedrich*, c.1798, Museum der Stadt, Greifswald.

■ Friedrich, *Portrait of the Artist's Sister Catharina Dorothea Sponholz*, c.1798, Staatsgalerie, Graphische Sammlung, Stuttgart. Catharina married the Protestant pastor August Sponholz.

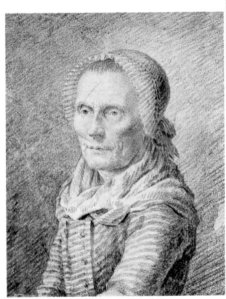

■ Friedrich, *Mutter Heiden*, c.1798, Stiftung Pommern, Gemäldegalerie und Kulturgeschichtliche Sammlungen, Kiel. After their mother's death in 1781, it was a nurse and long-standing friend of the family, affectionately called "Mutter Heiden", who took care of the ten children and kept house for Friedrich's father.

BACKGROUND

Dawn of a
new sensibility

By the time Johann Wolfgang von Goethe published his novel *The Sorrows of Young Werther* in Leipzig in 1774, the *Sturm und Drang* (storm and stress) literary movement had already caused a stir among young German writers. The absolute power of human reason as expounded by members of the Enlightenment movement no longer held sway, and the emphasis was now on a return to nature and a rediscovery of feeling and imagination. Goethe's novel tells of the love affair, which is never consummated, between Werther and Lotte and comes to a dramatic end with the hero's suicide. Beneath its surface plot of two people involved in an unhappy love affair, lies the confession of a sensitive artist who is unable to integrate into society, and is ultimately defeated. *The Sorrows of Young Werther* was enormously successful throughout Europe. The same ideals of freeing oneself from the rules and restrictions imposed by society also feature in works by Bürger, Lenz, the young Schiller, and by the greatest theorist of the *Sturm und Drang* movement, Johann Gottfried Herder. By the 1780s, however, Goethe, Schiller, and many other German intellectuals felt the need to re-establish a balance between reason and feeling and to harness the irrational forces of human nature within clearly defined boundaries. This paved the way for the German classical period and the philosophy of Immanuel Kant.

■ Right: Johann Heinrich Wilhelm Tischbein, *Goethe in the Campagna*, 1787, Städtische Galerie, Frankfurt. The painting was executed while Goethe was in Italy visiting the country's most famous sights.

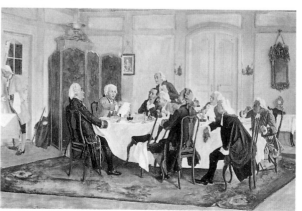

■ In Emil Doerstling's *Immanuel Kant and his Fellow Diners*, the German philosopher is most likely explaining to his guests the fundamental principles behind the philosophy of "pure reason". Unlike the *Sturm und Drang*, movement, this propounded the theory of the subordination of feeling to reason.

The Sorrows of Young Werther

In this epistolary novel, Goethe draws on three deeply personal experiences: his love affair with Charlotte Buff in Wetzlar in 1772, the suicide of his friend Karl Wilhelm Jerusalem following an unhappy love affair with a married woman, and Goethe's own parting from Maximiliane Laroche, who married the merchant Brentano in 1774. Reality and fantasy blend in a literary work that led in its day to "Werther fever" and that soon became the very symbol of *Sturm und Drang*. The name of the movement derives from the eponymous work (1776) by Klinger.

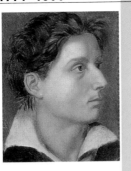

■ Jakob Friedrich Weckerlin, *Friedrich Schiller*, 1780. The writer is portrayed at the age of 21, when, influenced by *Sturm und Drang* ideals, he completed his first play, *Die Räuber* (The Robbers).

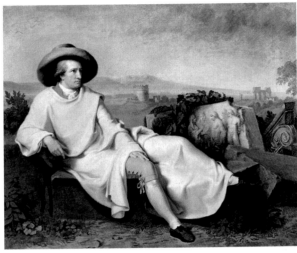

■ Right: Friedrich, *A Scene from Schiller's Die Räuber,* 1799, Kupferstichkabinett, Berlin. *Die Räuber,* written between 1777 and 1780, has as its central theme the difficult relationship between Karl Moor and his father and the conflict between Karl and his brother Franz.

■ Franz von Kügelgen, *Johann Gottfried Herder*, Freies Deutsches Hochstift, Frankfurt. Together with Johann Georg Hamann and Heinrich Wilhelm von Gerstenberg, Herder is regarded as one of the founders of the *Sturm und Drang* movement.

Student days in Copenhagen

In 1794, at Quistorp's suggestion, Friedrich decided to enrol at the Copenhagen Academy, which was at that time considered to be one of the most liberal institutions in Europe. Under the watchful eye of his tutors, including the landscape artists Juel and Lorentzen and the famous Nicolai Abildgaard, the young Friedrich learned to copy models in chalk and draw from life. Many sketches, watercolors, and drawings date from this period. Some show a strict adherence to academic rules, both in the choice of subjects – ruins, sarcophagi, temples – and in their draughtsmanship, whereas others reveal a more autonomous observation of nature and a detailed technique in the tracing of outlines, which would be fundamental in his future masterpieces. In Copenhagen, Friedrich met the painter Johan Gebhard Lund, a lifelong friend who would often be his guest in Dresden and to whom he would give his *Self-portrait* of 1800. In 1798, Friedrich left the Danish capital and, after a spell with relatives in Greifswald and Neubrandenburg, moved to Dresden.

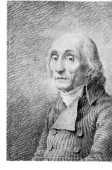

■ Friedrich, *Portrait of Ernst Theodor Brückner*, 1798, Kupferstichkabinett, Berlin. A translator of Homer, Brückner was father-in-law to the artist's brother Adolf and the pastor at Neubrandenburg.

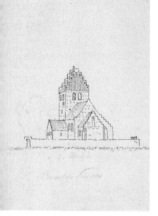

■ Above: Friedrich, *Church near Copenhagen* 1797–98, Staatsgalerie, Graphische Sammlung, Stuttgart.

■ Friedrich, *Study of Heads*, 1790–94, Museum der Stadt, Greifswald. During this period, Friedrich's sketches were usually of the human body or were based on mythological themes. Many of his drawings were careful copies of models drawn by the artist Johann Daniel Preisler, taken from a book he published in 1728. Friedrich was still not able to break away from the academic rules and develop his own artistic language.

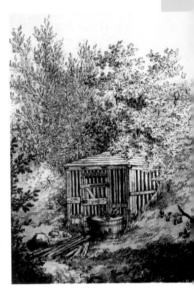

■ Friedrich, *Landscape with Figure of Hephaestus,* 1790–94, Museum der Stadt, Greifswald.

■ Nicolai Abraham Abildgaard, *The Archangel Michael Fighting with the Devil over the Body of Moses,* c.1782–85, Kunstmuseum, Aarhus. Abildgaard favored esoteric subjects drawn from mythology, history, and the Bible. This scene is taken from The Epistle of St Jude.

Copenhagen in Friedrich's day

■ Johann Heinrich Wilhelm Tischbein, *Friedrich Gottlieb Klopstock*, c.1800. With his famous odes Klopstock was able to breathe new life into German poetry and thus became the founder of modern German verse.

By the time Friedrich arrived in Copenhagen, the poet Friedrich Gottlieb Klopstock was no longer in the Danish capital, where he had lived from 1751 to 1771. Summoned to Denmark by Frederick V, Klopstock soon surrounded himself with a cultural circle made up of writers and poets, including von Gerstenberg, who had helped to start the *Sturm und Drang* movement. Klopstock's odes to nature and his religious poems exalting the values of love, friendship, and faith influenced Danish artists and writers for a long time. It was Quistorp and, later, Kosegarten, who introduced the young Friedrich to the works of Klopstock and the northern Pietist poets, and his tutor Abildgaard instructed him on what is known as the Northern Renaissance. Abildgaard had a wide knowledge of English literature, Nordic mythology, and the Gaelic legend of Ossian (whose odes the Scottish poet James Macpherson claimed to have translated but which were in fact penned by him). It was in this cultural climate that Friedrich began to develop his own vision.

■ Women's costume at the time of the Pietists was characterized by full, crinoline skirts trimmed with lace. Men wore tight-fitting hose and long frock-coats.

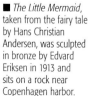

■ *The Little Mermaid*, taken from the fairy tale by Hans Christian Andersen, was sculpted in bronze by Edvard Eriksen in 1913 and sits on a rock near Copenhagen harbor.

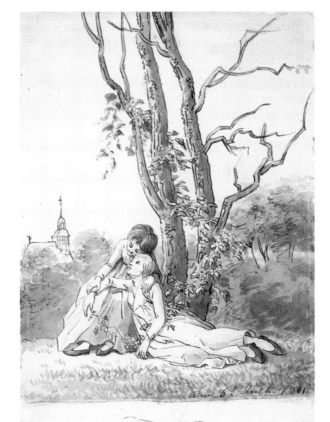

■ Friedrich, *Piece of Writing*, 1789, Kunsthalle, Hamburg. Friedrich's father believed in a strict, puritanical style of upbringing and demanded that his children carry out writing exercises such as this one.

■ Friedrich, *Two Girls Under a Tree*, 1801, Kupferstichkabinett, Dresden. The artist probably drew on the love poems of Kosegarten in order to produce this melancholy work.

15

Friedrich at the Dresden Academy

In the autumn of 1789, like so many other artists and intellectuals of his century, Friedrich went to Dresden, a city that had come to be known as the Florence of Germany for its beauty and rich art collections. Dresden further boasted an important school of landscape artists. Paintings by Johann Philipp Veith, Adrian Zingg, and Johann Christian Klengel were highly prized by collectors and Friedrich would surely have been familiar with them thanks to the many engravings reproducing their landscapes. Having enrolled at the Academy of Fine Arts, Friedrich, like many of his fellow-students, attended few lectures. He preferred to go on long, solitary walks around the art collections in the Gemäldegalerie and take trips into the countryside outside Dresden where he could draw from life. Trees, bushes, glimpses of the landscape, and windmills were the subjects he chose to reproduce during these solo excursions. Drawn in pencil on sheets that were often bound together in sketchpads, the works were later finished off in ink and lightly colored in with a wash. This first study period in Dresden came to an end in the spring of 1801, when Friedrich decided to return to Griefswald for a short time.

■ Friedrich, *Sailboats on a Rocky Coast*, 1798, Museum der Stadt, Grieifswald. In the sketches from this period, executed in pencil, ink, or, as here, in sepia, the motif of boats and sailing vessels first started to appear. This was to be a recurring theme in Friedrich's paintings. In his later works, boats came to symbolize man's transition from life on Earth to the next world.

■ Johann Christian Klengel, *Landscape with the Ruins of the So-called Temple of Minerva Medica in Rome*, 1790–92, Gemäldegalerie, Dresden. Ignoring Dutch models, Klengel was able to renew the tradition of German landscape painting.

■ The glass dome of Dresden's Academy of Fine Arts, surmounted by the winged figure of Victory, dates from the 19th century.

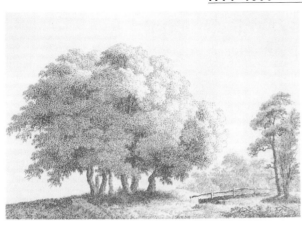

■ Right: Friedrich, *Trees and Bridge*, 1800, Herzog August Bibliothek, Wolfenbüttel. This engraving shows the artist's keen awareness of nature.

■ Friedrich, *Fishing Nets, Bushes, and Boats*, 1798, Private Collection. These pencil sketches represent Friedrich's earliest attempts to reproduce reality down to the smallest detail. Here, each individual leaf is rendered with extreme precision and fine detail.

■ Below: Friedrich, *Farmhouses on a Slope*, 1799, Herzog August Bibliothek, Wolfenbüttel. This scene is clearly influenced by Dutch landscape painting.

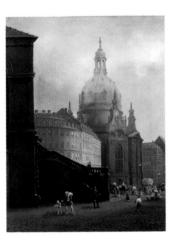

■ Left: Eduard Gärtner, *The Frauenkirche in Dresden*, 1838, Private Collection. The cornerstone of this church was laid in 1726.

17

Landscape painting before Friedrich

■ Claude Lorrain, *Landscape with Apollo and Mercury*, 1645, Galleria Doria Pamphili, Rome. Although based on a direct observation of nature, Lorrain chooses elements from reality in order to create an idealized landscape. Light, atmosphere, and space blend into a harmonious whole, thanks to the proportions of the scene and the use of contrast. Goethe himself said that Claude's paintings could "reach the highest level of truth, but contain no traces of reality!"

B etween the 16th and the 17th century, the Flemish artist Paul Bril was one of the first to use nature not as a mere background to religious or historical scenes but as a subject in its own right. Annibale Carracci, Domenichino, and particularly the French artists Nicolas Poussin and Claude Lorrain subsequently came to view landscape in relation to biblical and mythological figures. Their paintings became an idealized vision of landscape, with echoes of a mythical reality found somewhere in the past. In Claude Lorrain's paintings details blend into a landscape pervaded by light and golden reflections but the landscapes of the Dutch artists are sharp and crystal-clear, made up of layers that suggest the vibration of light. While still building up the composition according to the principles of the classical ideal, the landscapes of Ruisdael and Hobbema are no longer transfigurations of reality, but faithful and objective portrayals of the real world around them. In the 18th century, on the other hand, the evocative representation of nature increasingly solicited an emotional participation. In the paintings of Hubert Robert, Fragonard, and Wright of Derby, for example, the rendering of the landscape is conditioned by a sentimental interpretation, anticipating the 19th-century landscape paintings in which nature becomes a reflection of the artist's inner emotions.

■ Nicolas Poussin, *Landscape with Orpheus and Eurydice*, Musée du Louvre, Paris. In the distance is the smoke from a fire in Castel Sant'Angelo.

■ Salvator Rosa, *The Broken Bridge*, c.1641, Galleria Palatina, Florence. Anticipating the Romantics, Rosa interpreted nature in a subjective way.

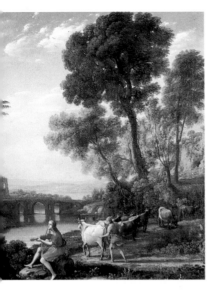

■ Paul Brill, *Landscape with Bearer*, 1610, Musei Civici, Brescia. Brill arrived in Italy in 1574 and remained there until his death in Rome in 1626. His paintings portray Rome's most hidden corners – half-buried ruins, spires, bell-towers – and scenes from everyday life.

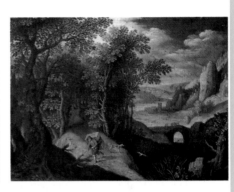

■ Meindert Hobbema, *Avenue at Middelharnis*, 1689, National Gallery, London. Although it adheres to the typical compositional structure of Dutch landscape painting (the trees like side-wings on a theatrical stage), Hobbema's country scene is very true to life.

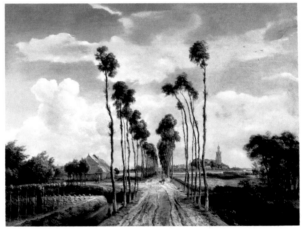

■ Jacob van Ruisdael, *Landscape Near Haarlem*, 1660, Thyssen-Bornemisza. Collection, Madrid. This Dutch painting does not show a natural scene that has been ennobled or created by the artist, but suggests careful observation and a faithful documentation of the landscape around Haarlem.

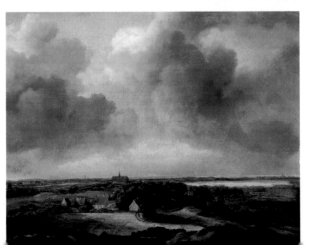

Friedrich, *View over the Elbe Valley*, c.1807, Gemäldegalerie, Dresden

The Rügen coastline

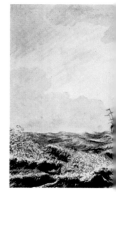

After spending the spring months of 1801 with relatives and friends in Greifswald and Neubrandenburg, Friedrich went to the island of Rügen, an ideal and much-admired setting, renowned for its steep ravines, prehistoric remains, and white cliffs. Stubenkammer, Wissower Klinken, and Kap Arkona are some of the mysterious-sounding places on Rügen mentioned in ancient Nordic songs. Enchanted by the intact landscape of the island, Friedrich was finally able to develop his own artistic language and style, breaking away from all previous models. The drawings he produced on this trip and the one he made in May 1802 reveal a confidence of touch and an ability to understand the changes in the marine landscape, elements that were missing from his previous sketches. Throughout this period, Friedrich also developed his personal philosophy. Influenced by his reading of Kosegarten, he came to perceive nature as a divine manifestation and art as a means of mediation between man and God. A faithful representation of nature now assumed a religious significance and became an evocation of the divine. "I must give myself up to all that surrounds me", he said, "I must be one with my clouds and rocks, in order to succeed in being what I am. I need nature in order to communicate with nature" – and with God.

■ Friedrich, *Wayfarer by a Milestone*, 1802, Staatliche Graphische Sammlung, Munich. The tired and melancholy wayfarer pauses to rest.

■ The white cliffs of Wissower Klinken are Rügen's major attraction. The island's coastline is about 600 kilometers (372 miles) long.

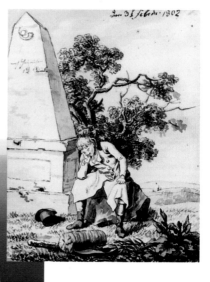

■ Jakob Philipp Hackert, *The Baltic Sea near Rügen*, 1764, Kupferstichkabinett, Berlin. Hackert's engravings give us a glimpse of Rügen. The artist stayed on the island during the 1760s, when he was invited to decorate the summer residence of Baron Von Olthoff.

■ Friedrich, *Boy Sleeping on a Grave* 1802, Herzog August Bibliothek, Wolfenbüttel. In Friederich's work, the theme of sleep is associated with death.

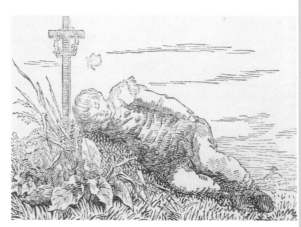

■ In this pen-and-ink drawing, executed in 1801 (Museum der Bildenden Künste, Leipzig), Friedrich portrays the beach and cliffs of Stubbenkammer on Rügen, located in the northeastern part of the island near the present-day Jasmund National Park.

■ Left: Friedrich, *Hut with Well on Rügen*, 1802, Kunsthalle, Hamburg. The low horizon is recurrent in Friedrich's work.

23

Heroic landscapes: Reinhart and Koch

Johann Christian Reinhart and Joseph Anton Koch spent most of their life in Italy. Reinhart went to Rome in 1789, Koch in 1797. During those years, German travellers, intellectuals, and artists gravitated towards the villa on the Pincian hill, which had previously been the summer residence of the Ambassador of the Order of Malta. Here, Carl Ludwig Fernow gave lessons in aesthetics according to Kant's principles: the purpose of art was to represent nature, not to imitate it, but from the vantage point that nature must follow a clearly defined original plan. Through the artist's imagination art must create works able to synthesize such an idea. Reinhart and Koch, who were already producing landscapes in the classical tradition, were struck by Fernow's words and tried to translate the scholar's theories into their own paintings. A further source of inspiration was the drawings and designs, taken from ancient mythology, of the Danish-German artist Carstens. Reinhart and Koch thus became the main exponents of the heroic landscape seen as the marriage of nature and history.

■ Johann Christian Reinhart, *Italian Landscape*, 1813, Museum Thorvaldsen, Copenhagen. Reinhart's models were Nicolas Poussin (1594–1665) and Gaspar Dughet (1615–75), both of whom painted landscapes in the classical manner, combining the observation of reality with an idealistic vision of nature.

■ Joseph Anton Koch, *Apollo Among the Shepherds of Thessaly*, 1834–35, Museum Thorvaldsen, Copenhagen. Exiled in Thessaly for killing a cyclops, Apollo uses music to civilize the shepherds.

■ Joseph Anton Koch, *Dante and Virgil on Geryon*, c.1822, Museum Thorvaldsen, Copenhagen. This watercolor was commissioned by Thorvaldsen.

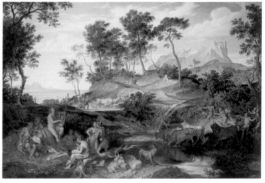

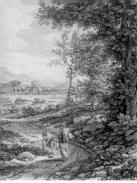

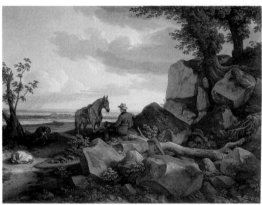

■ Joseph Anton Koch, *Heroic Landscape with Rainbow*, 1802, Staatliche Kunsthalle, Karlsruhe. Koch initially shared lodgings in Rome with the famous Danish sculptor Thorvaldsen.

■ Johann Christian Reinhart, *Italian Landscape with Resting Rider*, 1835, Museum Thorvaldsen, Copenhagen. This picture of the Roman campagna, different from the artist's more typical heroic landscapes, was exhibited in Rome in 1837 by the Association of German Artists.

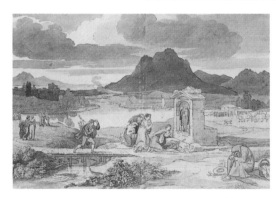

■ Georg Augustus Wallis, *Ave Maria*, c.1806, Museum Thorvaldsen, Copenhagen. The original *Ave Maria* painting, which has been lost and is only known to us through this watercolor, was the object of much enthusiasm among the artist's contemporaries.

Summer

Painted in 1807, *Summer* was one of Friedrich's first attempts at oil painting (now in the Neue Pinakothek, Munich). Sadly, its companion piece, *Winter*, was destroyed in 1931.

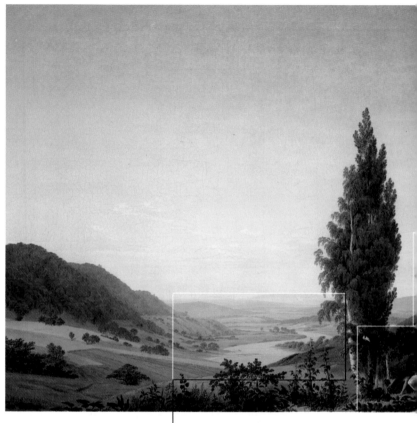

■ The gentle slopes and the line of the horizon that stretches out to infinity clearly owe much to the 17th-century landscape tradition.

■ The dense foliage on the trees on the hill, together with the slopes on the left, act as props for the composition. This device is borrowed from classical landscape artists such as Claude Lorrain and Poussin.

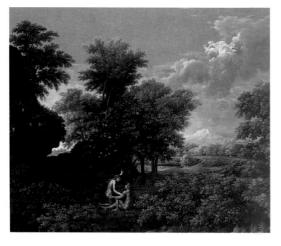

■ The two lovers embracing under the pergola and the two doves among the branches emphasize the symbolic nature of the painting. Friedrich is portraying an allegory of earthly love and divine creation, which manifests itself in the infinite variety of the vegetation. In *Winter*, on the other hand, the young couple is replaced by an ageing wayfarer: the joy of life gives way to the awareness of death.

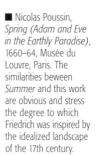

■ Nicolas Poussin, *Spring (Adam and Eve in the Earthly Paradise)*, 1660–64, Musée du Louvre, Paris. The similarities beween *Summer* and this work are obvious and stress the degree to which Friedrich was inspired by the idealized landscape of the 17th century.

Romantic yearning

■ Right: shown here is the title page of *Des Knaben Wunderhorn*, a collection of popular German tales published in Heidelberg in 1808 and edited by Clemens von Brentano and Achim von Arnim.

Towards the end of the 18th century the younger German generation mounted a cultural revolt against the classicism of Schiller and Goethe, and attempted to establish a synthesis between the principles of the Enlightenment, *Sturm und Drang*, and classicism. The importance of the imagination and the irrational, combined with reason and feeling, were vehemently endorsed. The early Romantics, who initially met at the University of Jena and among the literary circles of Berlin, rediscovered the historical period of the Middle Ages and renewed their interest in popular songs and traditions. While Goethe's works tended towards universal order and harmony within pre-established limits, the poetry of Novalis revealed a deep sense of yearning for the infinite and for the attainment of everlasting happiness. The philosophers Fichte, Schelling, and the brothers Schlegel interpreted the Romantic ideals that were developed in poetic form by Ludwig Tieck, Wilhelm Heinrich Wackenroder, and, later, Clemens von Brentano and E. T. A. Hoffmann. A work of art must combine poetry, music, and religion; only thus could it constitute a link with the universe and mediate between man, nature, and God. The relationship between the external and the inner world would then be consummated in art.

■ *Johann Gottlieb Fichte*, 1808, aquatint by Friedrich Jügel, from a portrait by Heinrich Anton Dähling. Fichte taught at the University of Jena between 1798 and 1799.

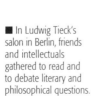

■ Ernst Theodor Amadeus Hoffmann was a writer, composer, music critic, artist, and caricaturist.

■ In Ludwig Tieck's salon in Berlin, friends and intellectuals gathered to read and to debate literary and philosophical questions.

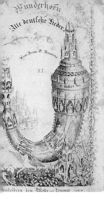

The fairy tale

The fairy tale *Ondine*, published by Baron Friedrich de la Motte-Fouqué in 1811, tells of the love affair between the sea creature Ondine and the knight Hildebrand. During the Romantic period, the fairy tale became a very popular literary genre because of its popular and mythical origins and the opportunities it offered for the imagination. The brothers Grimm published a collection of German fairy tales and legends and fairy stories written by the Danish Hans Christian Andersen were successful throughout the world. Many writers, including Tieck and Brentano, retold tales from popular mythology, giving them a new-found literary status.

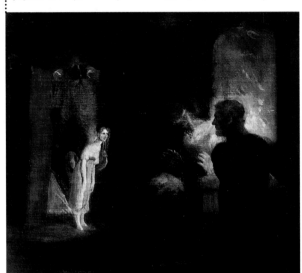

■ Henry Fuseli, *Ondine Arrives at the Fishermen's House*, 1821, Kunstmuseum, Basel. The inspiration for this painting comes from the fairy tale by Friedrich de la Motte-Fouqué.

■ Friedrich, *The Romantic Reader*, 1801, Kupferstichkabinett, Dresden.

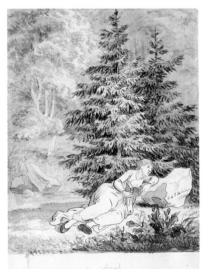

■ F. K. Hiemer, *Friedrich Hölderlin*, Schiller Museum, Marbach. Hölderlin (1770–1825) was influenced by both the Romantic poets and the classical German works of Goethe and Schiller.

■ Engraving by Eduard Eichens showing the poet Friedrich Freiherr von Hardenberg (Novalis), 1845.

29

LIFE AND WORKS

Friedrich and Schubert: the quest

■ Friedel, *Heinrich von Kleist*, 1801, Staatsbibliothek, Berlin. It was Kleist, pictured here by the miniaturist Friedel, who introduced Friedrich to the "Phoebus" circle of intellectuals.

Back in Dresden in the summer of 1802, Friedrich gained a degree of recognition among art lovers and collectors thanks to his sepia drawings. His new-found fame enabled him to come into contact with writers and intellectuals such as Ludwig Tieck, the philosopher Gotthilf Heinrich Schubert, and the poet and dramatist Heinrich von Kleist. The ideas that prevailed in these literary and artistic circles were inspired by Schelling's philosophy of nature as well as the writings of the brothers Schlegel and the philosopher Schleiermacher. Friedrich was thus able to broaden his own mystical-religious leanings and to develop an artistic language that would adequately express them. A fundamental notion was the consideration of natural phenomena as a manifestation of the Absolute, a pantheistic belief that held that each natural phenomenon is endowed with a soul. Just as Friedrich's landscapes were charged with religious significance, so too in the music of Franz Schubert (particularly the lieder) is the divine suggested in the union of sound and word. Both artists were interested in reviving Germany's ancient myths and popular traditions, a trend that characterizes the Romantic movement in Germany as a whole.

■ Below: Moritz von Schwind portrays a musical soirée at the house of Joseph von Spaun, one of Schubert's old friends (Schubert Museum, Vienna).

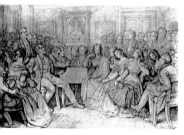

■ Franz Schubert is pictured at the piano surrounded by his friends, including Johann Michael Vogl and Joseph von Spaun.

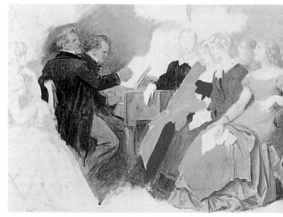

■ Friedrich, *Dolmen in the Snow*, 1807, Gemäldegalerie, Dresden. The oak trees keep a vigil over the tomb of an unknown hero of the past.

■ Below: the score of Schubert's *Schäfers Klagelied*. Schubert drew on popular medieval German songs for his lieder. Many Romantic artists looked to the Middle Ages for inspiration.

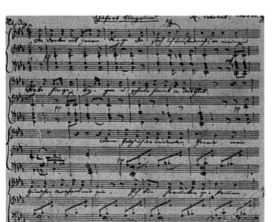

Schubert

Schubert composed more than 600 lieder, nine symphonies, and seven masses, as well as chamber music and orchestral concertos. His only public performance, on March 26, 1828, was very successful, but he always preferred musical evenings in the company of friends. Painted by Wilhelm August Rieder in 1875, this portrait now hangs in the Schubert Museum in Vienna.

BACKGROUND

The rise of Napoleon

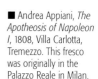

After his military triumphs in Italy and his victory over the Austrians at Marengo in 1800, the rise of Napoleon Bonaparte, a mere officer in the artillery, seemed unstoppable. The people hailed him as savior of France and in 1802 he made himself first consul for life, amending the constitution and giving himself the powers of a monarch. This was still not enough for him, however, and on December 2, 1804, he had himself crowned emperor at Notre-Dame in Paris in the presence of Pope Pius VII. From this moment onwards Napoleon began a policy of expansion aimed at establishing France's sovereignty throughout Europe. War upon war followed without interruption involving the armies of the major states of the old continent. Italy and Spain fell under Napoleonic rule and the Holy Roman Empire disappeared from the map to make way for a coalition of German states that were under French control. Discontent and patriotic fervor grew, particularly in Germany, and pamphlets inciting the people to insurrect were printed and distributed everywhere. The only European powers still to be spared were England and Russia. In 1812, Napoleon decided to wage war against the kingdom of Tsar Alexander I and invaded Russia. This disastrous decision signalled the beginning of Napoleon's decline.

■ Andrea Appiani, *The Apotheosis of Napoleon I*, 1808, Villa Carlotta, Tremezzo. This fresco was originally in the Palazzo Reale in Milan.

■ This caricature by James Gillray shows Napoleon and the English prime minister William Pitt carving up the world.

■ The Empire style was characteristic of the Napoleonic age and rapidly spread throughout Europe.

■ Andrea Appiani, *Portrait of Napoleon, Emperor and King of Italy*, Palazzo di Montecitorio, Rome (on loan from the Pinacoteca di Brera, Milan).

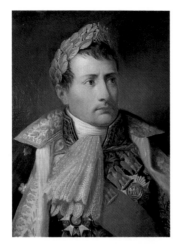

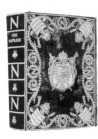

■ This is the first edition of the *Code Napoléon*, bound in black velvet and edged in gold (Bibliothèque Nationale, Paris). The codification of the civil law was completed in 1804. Known as the *Code Napoléon*, it was introduced to all the territories that came under Napoleonic rule. In Baden, Germany, Napoleonic law remained in force until 1900.

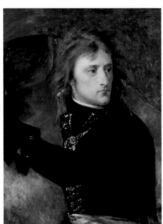

■ Below: The treaty of the Peace of Campoformio (1797), agreed between Napoleon and the Austrian empire, forced the Hapsburgs to surrender their claim to Italian territories.

■ Left: Antoine-Jean Gros, *Bonaparte at Arcole*, 1796, Musée du Louvre, Paris. Gros was one of Napoleon's foremost portrait artists.

■ James Gillray, *Napoleon Directing the Plunder of the French Army in Italy*, 1814, Civica raccolta delle stampe Bertarelli, Milan.

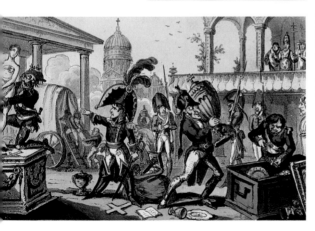

Friedrich, *Landscape with Rainbow*, 1810, Museum Folkwang, Essen

Inner landscapes

Winter, symbol of Christian hope

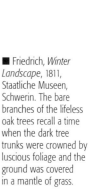

Religiously inspired poems and aphorisms bear witness to Friedrich's deep faith; he had grown up in a Protestant environment governed by the strictest moral rules. For him, painting became a means through which to communicate with God, and art turned into prayer and mission. Images of foggy landscapes, thick blankets of snow, and shadowy Gothic churches are heavy with religious symbolism and evoke a feeling of Christian hope. Winter, which precedes the rebirth of nature and life, symbolizes the Christian notion of the Resurrection, and death is not the end, but the beginning of life in the next world. For this reason, Friedrich often included ruins and cemeteries in his winter landscapes; for him, death and life blended into a single image and the painting became an allegory of the ephemeral quality of life and the cyclical nature of events – symbolized by evergreen fir trees. The transitory nature of life is seen from a perspective of hope, of faith in the continuity between life on earth and an eternal afterlife. In these snow-bound landscapes the human presence is reduced to small wayfaring figures encircling the wizened trunks of oak trees with branches as gnarled as roots. These tiny figures are able to discover the divine mystery through nature.

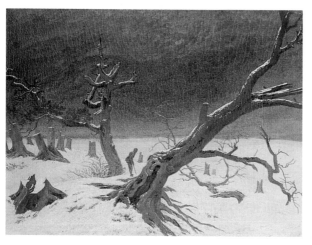

■ Friedrich, *Winter Landscape*, 1811, Staatliche Museen, Schwerin. The bare branches of the lifeless oak trees recall a time when the dark tree trunks were crowned by luscious foliage and the ground was covered in a mantle of grass.

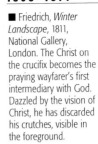

■ Friedrich, *Winter Landscape*, 1811, National Gallery, London. The Christ on the crucifix becomes the praying wayfarer's first intermediary with God. Dazzled by the vision of Christ, he has discarded his crutches, visible in the foreground.

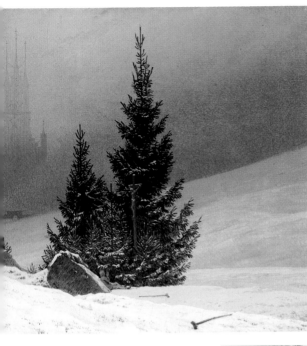

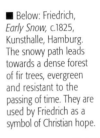

■ Below: Friedrich, *Early Snow,* c.1825, Kunsthalle, Hamburg. The snowy path leads towards a dense forest of fir trees, evergreen and resistant to the passing of time. They are used by Friedrich as a symbol of Christian hope.

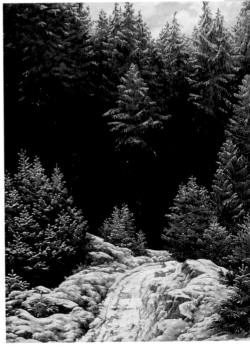

■ Below: Friedrich, *Snow-Covered Hut,* 1827, Nationalgalerie, Berlin. Almost a tomb concealed under a blanket of snow, the abandoned hut seems to symbolize death, which enables man to enter the next world. The boarded-up door points to a time when the hut was perhaps inhabited by a solitary nature lover.

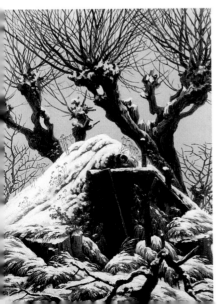

Philipp Otto Runge

■ Philipp Otto Runge, *The Artist's Parents*, 1806, Kunsthalle, Hamburg. The grave demeanor and severe features of Runge's parents suggest strictness and diffidence, in stark contrast to the light-hearted expressions of the grandchildren.

The first meeting between Philipp Otto Runge and Friedrich took place in 1801, when Runge decided to stop off in Greifswald while visiting his parents in the nearby town of Wolgast. They met occasionally throughout the ensuing years, but whether a friendship ever developed between these two great protagonists of German Romantic painting remains uncertain. Born in 1777, Runge received his artistic training at the Copenhagen Academy a few years after Friedrich had left the Danish capital for Dresden. Like Friedrich, Runge wanted to express religious feeling through art, and to break away from traditional Christian iconography. Whereas Friedrich used visual experience as a starting-point from which to invest his landscapes with religious symbolism, Runge transformed concepts and theories into allegorical landscapes. The flower became an allegory of the Creation and stars took on the symbolic meaning of eternity. Runge's fundamental ambition was to produce a complete work of art (*Gesamtkunstwerk*), in which painting, poetry, and music would blend into a harmonious whole, and viewing a painting would be no different from listening to symphonies or poems.

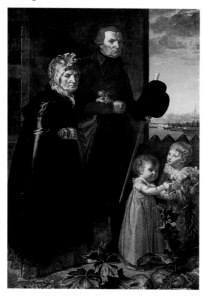

■ Philipp Otto Runge's family home was in the Kronwieckerstrasse in the small Hanseatic town of Wolgast.

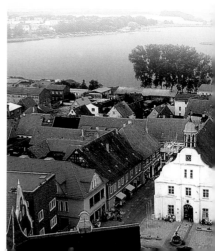

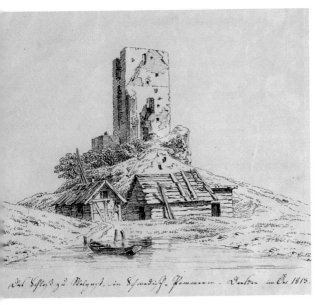

■ Friedrich, *The Ruins of Wolgast Castle*, 1813, Pushkin Museum, Moscow. For just over a century, from 1523 to 1625, Wolgast was the seat of the dukes of Pommern-Wolgast.

■ Below: Philipp Otto Runge, *Morning*, 1808, Kunsthalle, Hamburg. This painting is the best in the *Times of the Day* series, which was never completed. Morning is allegorically represented by Aurora, the dawn.

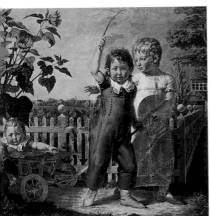

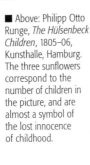

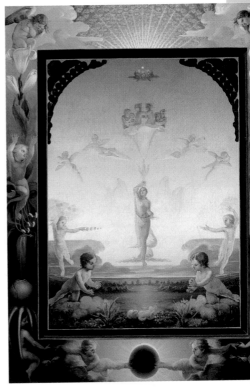

■ Above: Philipp Otto Runge, *The Hülsenbeck Children*, 1805–06, Kunsthalle, Hamburg. The three sunflowers correspond to the number of children in the picture, and are almost a symbol of the lost innocence of childhood.

The Cross in the Mountains

Now in Dresden's Gemäldegalerie, the *Cross in the Mountains* was painted between 1807 and 1808 as an altarpiece for the private chapel of Tetschen Castle in Bohemia.

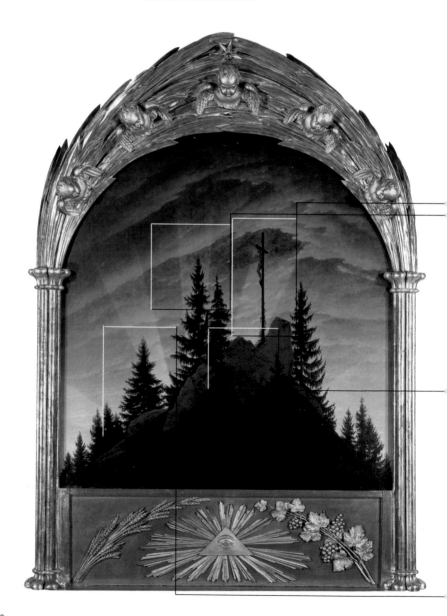

■ The setting sun facing the crucified Christ represents an image of God, the universal lifegiver, while the Cross, fixed solidly into the rock, is an emblem of the strength of human faith.

■ The pine trees around the Cross symbolize the hope vested by man in Christ. The painting captures the moment when humanity is set before the omnipresent divinity.

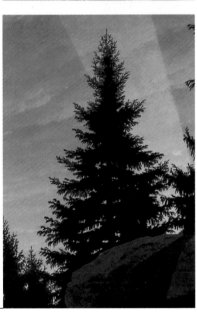

■ Basilius von Ramdohr, an art critic of the time, disapproved of this work chiefly because of the absence of the most elementary rules of perspective. Indeed, considering the distance, the detailed view of the rock is not lifelike.

■ Three pine trees correspond to the three rays of light: this is an image of the Trinity, which is echoed in the lower part of the frame (designed by Friedrich himself). The origin of the light remains a mystery, hidden behind the trees.

BACKGROUND

Art and the crisis in Christian iconography

Towards the end of the 18th century religion and the Christian artistic tradition experienced a crisis that was to bring about a profound change in art. Artists and writers dreamed of giving birth to a new spiritual age, of which they were the main preachers. Religious feeling changed and even the forms and symbols of art were transformed. The complex formulae of the Christian iconography that had been seen in previous centuries was replaced by solitary figures contemplating the infinite or Gothic ruins set in sweeping landscapes. In the visionary works of William Blake, man was both creature and creator, God took on a human essence, and Creation came to be identified with the fall of man the God. The paintings of Jacob Carstens viewed the origin of the universe in terms of cosmogony, with the figure of God disappearing completely. In Ingres, too, the figure of God is absent – only to be replaced by Napoleon assuming celestial powers. In Goya, the image of Christ is echoed in that of Spanish patriots shot by a French army firing squad. Religious iconography thus came to service the cult of the modern hero.

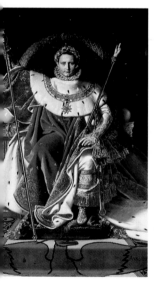

■ Jean-Auguste-Dominique Ingres, *Napoleon I on the Imperial Throne*, 1806, Musée de l'Armée, Paris. The majestic figure of Napoleon sits on the throne of God the Father from Van Eyck's Ghent altarpiece.

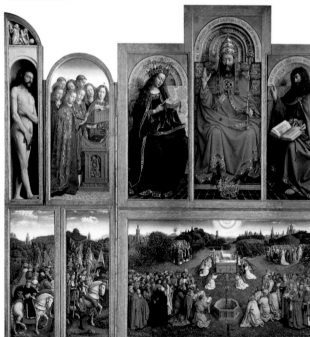

■ Right: Jan van Eyck, *Adoration of the Lamb*, 1432, St Bavo, Ghent. In 1986, the altarpiece was moved from its original position in the cathedral's Vijd Chapel to the baptistry.

■ Francisco Goya, *The Agony in the Garden* 1819, Colegio de los Padres Escolapios de San Antón, Madrid.

■ Below: Asmus Jakob Carstens, *Agathon's Gathering*, 1793, Museum Thorvaldsen, Copenhagen. Here, the apostles are replaced by figures from Greek mythology.

■ Right: William Blake, *Newton*, 1795, Tate Gallery, London.

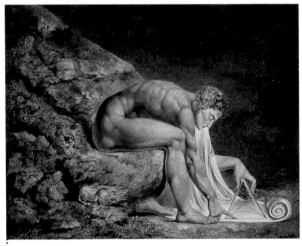

William Blake

A poet, painter, and engraver, William Blake (1757–1827) was deeply interested in the mystical trends of his day. According to Blake, man lost the harmony of his origins after the fall from grace and all of human life was thus a desperate quest for that lost sense of unity. Blake was obsessed by the problem of good and evil and his visionary works, both in art and literature (for example, his illustrations for the Bible and Milton's *Paradise Lost*), aimed to lead both back to an original positive energy and to create an eternal harmony of opposites.

43

Abbey in the Oakwood

This small painting was executed between 1809 and 1810 and is now in Berlin's Schloss Charlottenburg. The *Abbey in the Oakwood* was shown in 1810 at an exhibition held by the Academy of Fine Arts in Berlin.

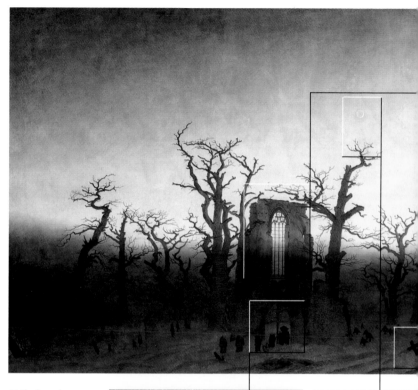

■ The funeral procession of monks, moving slowly towards the cross inside the Gothic portal of the ruined abbey, seems to emerge from the white, snow-covered ground. The tiny black dots of their clothing blend with the sparse graves in the cemetery.

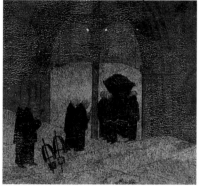

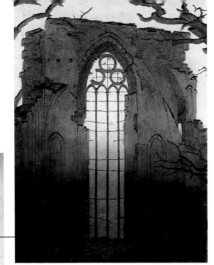

■ The Gothic ruin, inspired by the ruined Cistercian Abbey of Eldena near Greifswald, may symbolize the religious feeling of a bygone age. It seems to evoke a deep yearning for death, almost becoming a meditation on the transitory nature of life.

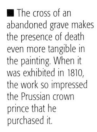

■ The cross of an abandoned grave makes the presence of death even more tangible in the painting. When it was exhibited in 1810, the work so impressed the Prussian crown prince that he purchased it.

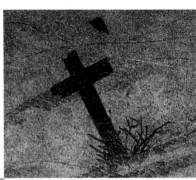

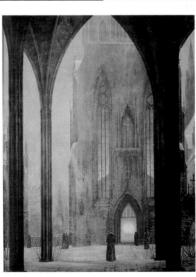

■ The unnatural, almost divine light, to which the oak trees stretch out their branches, comes from an unknown source. The trees evoke a sense of vitality and movement, contrasting sharply with the harsh rigidity of the tombstones and the lifeless Gothic architecture.

■ Left: Ernst Ferdinand Oehme, *Cathedral in Winter*, 1828, Gemäldegalerie, Dresden. Here, Oehme, one of Friedrich's admirers and followers, borrows some of the figurative elements found in *Abbey in the Oakwood*: the Gothic architecture, the monks, the mist, and the mysterious, all-pervasive light of unknown origin.

1808–1814

Travels with Kersting

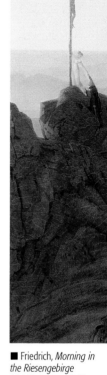

■ Friedrich, *Morning in the Riesengebirge* (detail), 1810–11, Schloss Charlottenburg, Berlin. The figures in this picture were painted by Kersting.

With a suitcase over their shoulder and sketchbooks in hand, in July 1810 Friedrich and the painter Georg Friedrich Kersting took a trip to the Riesengebirge, the mountains south of Dresden. The hastily sketched pencil drawings of the green slopes, the snow-capped peaks, and the rocky landscape before them formed a precious repertory that Friedrich used in his paintings for years to come. Friedrich spent many enjoyable days quietly drawing and contemplating nature, the only sounds coming from the leaves rustling in the wind and the birds singing in the trees. His experience of nature took on a religious meaning, in so far as nature was the means whereby man could establish a link with God. Nature became the symbol of a harmonious unity in which the eternal process of divine creation was made manifest. Elements of the landscape captured in different places and at different times of the day enabled him to project what he saw within himself onto the landscape before him, transforming his painting into a reflection of his own sensibility and inner vision of the world.

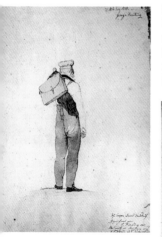

■ Above: Georg Friedrich Kersting, *Friedrich During his Journey with Kersting,* 1810, Kupferstichkabinett, Berlin.

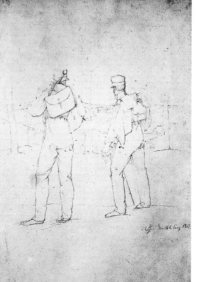

■ Georg Friedrich Kersting, *Friedrich and the Sculptor Kühn During their Journey Through the Harz Mountains,* 1811, Kupferstichkabinett, Berlin. Christian Gottlieb Kühn was the sculptor who made the frame for *The Cross in the Mountains.*

■ Right: Friedrich, *Mountain Landscape*, after 1830, Pushkin Museum, Moscow. Even in his later works Friedrich returned to the drawings he made during his only stay in the Riesengebirge. It is almost as if he wanted to relive the days he spent drawing with Kersting and exploring the awesome mountains through his painting.

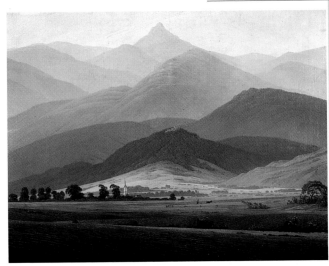

■ Below: Friedrich, *Bohemian Landscape*, c.1810, Staatsgalerie, Stuttgart. After their journey through the Riesengebirge, Friedrich and Kersting returned to Dresden via Bohemia. This painting was purchased by Count Von Thun-Hohenstein, who also commissioned *The Cross in the Mountains*.

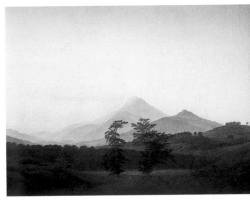

■ Friedrich, *Self-portrait*, c.1810, Kupferstichkabinett, Berlin. This charcoal drawing is the last in Friedrich's series of self-portraits, conceived as moments of reflection and enquiry into his own inner self.

■ Below right: Friedrich, *Morning in the Riesengebirge* 1810–11, Schloss Charlottenburg, Berlin. From the highest summit the cross overlooks the earthly world, which appears as an infinite sea of fog out of which the mountain peaks rise up.

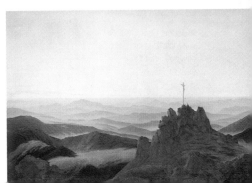

BACKGROUND

The irresistible lure of Italy

Brunelleschi's dome, Castel Sant'Angelo, and the Campidoglio are all Italian sights painted by foreign artists who, drawn principally by the myth of Rome and its classical ruins, travelled to Italy on the Grand Tour in the second half of the 18th century. "*Et in Arcadia ego,*" exclaimed Goethe on his arrival in Italy in 1786 accompanied by the German painter Johann Wilhelm Tischbein. From Rome, Goethe continued his Italian journey in the company of the landscape artist Christoph Kniep, and in Naples visited Jakob Philipp Hackert, the famous painter of the Bourbons, whose clear, documentary views even earned him the admiration of Catherine the Great. The usual meeting place in Rome for artists and travellers from northern Europe was the Villa Malta, where they could meet the artists Koch and Reinhart, or Angelica Kauffmann who, after an absence of almost 20 years, had settled for good in the city with her husband Antonio Zucchi. Michael Wutky, Johan Christian Dahl, and Franz Ludwig Catel are just some of the northern European artists whose names are closely associated with many places in Italy. Up until the mid-19th century, Italy remained a favorite destination for many European travellers curious to see for themselves the historical sites and scenery so familiar to them through paintings and literature.

■ Angelica Kauffmann, *Composition*, c.1780, Burlington House, London. This work, which used to hang in the entrance of London's Somerset House, echoes the teachings of Winckelmann, who advocated an art inspired by classical antiquity.

■ Johan Christian Clausen Dahl, *Eruption of Vesuvius*, 1821, Statens Museum for Kunst, Copenhagen. From 1764 onwards, and particularly in 1767 and 1779, Mount Vesuvius frequently erupted, providing foreign visitors to Naples with spectacular sights.

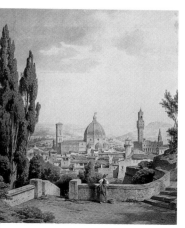

■ Albert Emil Kirchner, *Florence*, Kunsthalle, Hamburg. Florence was one of the cities included in the Grand Tour.

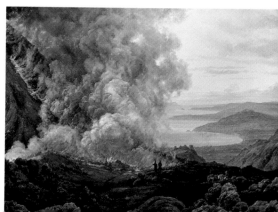

48

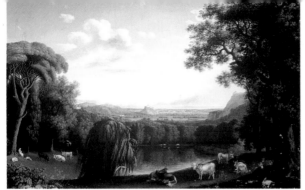

■ Jakob Philipp Hackert, *The English Garden at Caserta with a View of Vesuvius*, 1797, Kunstmuseum, Düsseldorf. As court painter to Ferdinand IV, king of the Two Sicilies, Hackert painted mainly landscapes around Naples and life at court.

■ Franz Ludwig Catel, *Crown Prince Louis at the Spanish Inn in Rome*, 1824, Neue Pinakothek, Munich. Prince Louis of Bavaria was often seen in the company of foreign painters and sculptors near Rome's Piazza di Spagna.

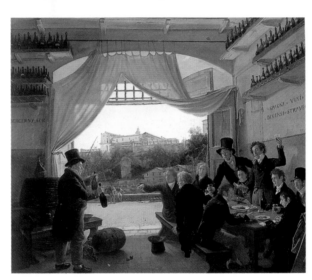

■ Johan Christian Clausen Dahl, *Villa Malta in Rome*, 1821, Nasjonalgalleriet, Oslo. Anna Amalia, Duchess of Saxe-Weimar, was also a guest at the Villa Malta.

Villa Malta

In 1794, Villa Malta, once the summer residence of the ambassador of the Order of Malta, became the residence of Prince Frederick Augustus, who made it the seat of the northern colony in Rome. A lover of art and archeology, the prince ordered Fernow to organize classes in aesthetics, set up a reading circle, and create a library at the villa. Within a few years, the villa became the Roman headquarters of northern European intellectual life and a favorite meeting place for artists and writers. In 1827, the house was bought by King Louis I of Bavaria.

Monk on the Seashore

Painted between 1808 and 1810, this work, now in Berlin's Schloss Charlottenburg, was exhibited with *Abbey in the Oakwood* at the Berlin Academy of Fine Arts in 1810. It was purchased by Crown Prince Frederick of Prussia.

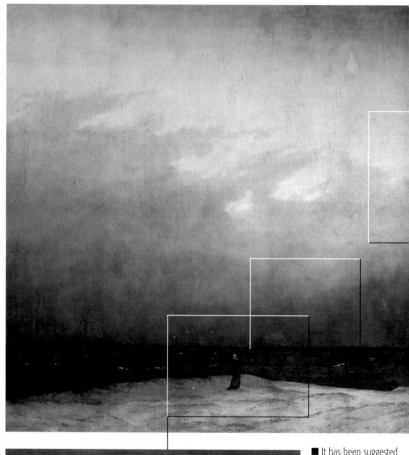

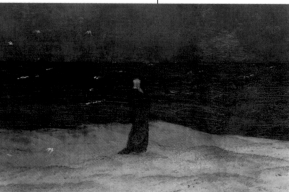

■ It has been suggested that Friedrich sought to portray himself as the monk, deeply absorbed in the contemplation of nature. As the only vertical element in the painting, the monk helps to convey the immensity of the landscape and points

■ The luminous part of the painting covers more than half of the canvas. Since it is not marked out on each side by the usual "props" required by landscape tradition, but juxtaposed with the small solitary figure of the monk, it manages to express a sense of immensity.

■ Only a small, isolated flock of low-flying seagulls enlivens this infinite sky, heightening the viewer's sense of solitude and awe before the seemingly infinite expanse of space.

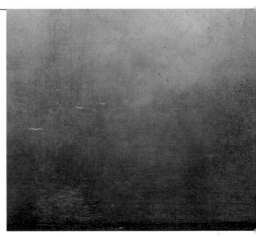

to the contrast between life on earth and eternal life. The work is almost a symbol of man's solitude, his presence reduced to a tiny figure that cannot participate in the process of nature, but must bow to its infinity.

Cloud studies:
Friedrich and Cozens

Friedrich's delicate, ephemeral clouds are the bearers of a mystery that begs to be solved. They are the central feature in an unknown, hidden world to which the viewer has no access. In Friedrich's work, the white masses that envelop the landscape stimulate the imagination by urging viewers to project something of themselves onto the inner core of the painting. The landscapes by the English artist John Robert Cozens (1752–97) are, similarly, views that stem from man's inner world and are dominated by emotion. In *Lake Nemi*, painted during the artist's first trip to Italy (1776–79), Cozens goes beyond reality, heralding the Romantic direction that Friedrich's paintings would take. As in Friedrich's work, Cozens' clouds are much more than a simple metereological phenomenon to be examined. Clouds spreading out after a storm, wispy clouds gently borne along by the wind, clouds heavy with rain: all are symbols of the moment and of the passing of time. Through their cloud studies, both Friedrich and Cozens tried to grasp the ineffable and reach out to the mystery of life, almost in anticipation of the abstract paintings of the 20th century.

■ Friedrich, *Clouds Spreading Out*, 1821, Kunsthalle, Hamburg.

■ Below: John Robert Cozens, *Shepherds' Hut Between Naples and Portici*, Victoria and Albert Museum, London. Cozens' second trip to Italy took place between 1780 and 1783.

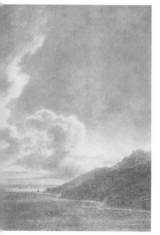

■ John Robert Cozens, *Vietri in the Evening with Raito in the Background* (detail), Private Collection, London.

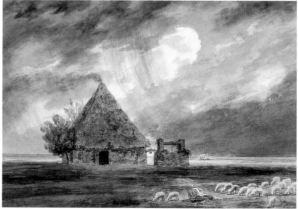

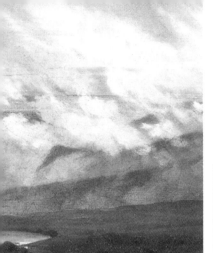

■ Friedrich, *Northern Sea in the Moonlight* (detail), 1824, Národní Galerie, Prague. In an almost apocalyptic vision, a dazzling array of yellow and purple hues tinge the clouds, which cast a shadow over the moonlight. The use of purple in connection with the moon expresses the typically Romantic yearning for distant, unreachable places.

■ Below: John Robert Cozens, *Padua*, Tate Gallery, London. John Constable described Cozens as the greatest genius ever to grace landscape painting.

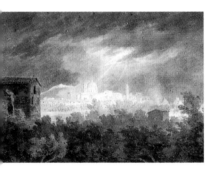

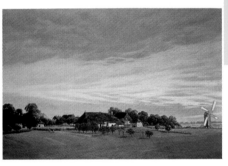

■ Friedrich, *Flat Country Landscape* 1823, Schloss Charlottenburg, Schinkel Pavillon, Berlin.

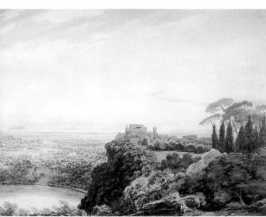

■ John Robert Cozens, The *Lake of Nemi Looking Towards Genzano*, 1777, Whitworth Art Gallery, Manchester.

The Napoleonic Wars

Ⅰn June, 1812, Napoleon's army, made up of more than 600,000 men, proceeded in its long march towards Moscow. Starving and cold, Napoleon and his troops reached the Russian capital after three arduous months. A few days later Moscow was ablaze as the Russian soldiers indiscriminately set fire everywhere. Napoleon and his army were forced to retreat. His men were unable to survive the harsh Russian winter without food and the troops' return journey was disastrous: more than 10,000 soldiers died. After years of victory, France was defeated and, soon after, in the autumn of the following year, Napoleon suffered a second defeat at Leipzig against the combined military forces of Russia, Prussia, Austria, England, and Sweden. Exiled to the island of Elba, he managed to return to France in order to challenge his adversaries once again. On June 18, 1815, however, he suffered his final and most humiliating defeat at Waterloo. Napoleon died six years later, in exile on the island of St Helena in the Atlantic Ocean.

■ Emperor Francis I of Austria received Tsar Alexander I of Russia and King Frederick William III of Prussia on September 25, 1814, at the gates of Vienna.

■ Giuseppe Bernardino Bison, *Prince von Schwarzenberg Announcing Victory over Napoleon to the Allied Monarchs*, Musei Civici di Storia e Arte, Trieste.

■ Ludwig Streitenfeld, *The Last Emperor of the Holy Roman Empire, Francis II, Dressed in the Imperial Robes*, 1874.

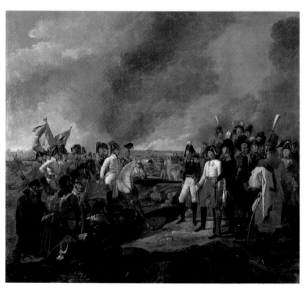

■ On a visit to the cities that came under French control, Napoleon entered Düsseldorf on November 3, 1811.

■ Before he was banished to St Helena (shown here in an ink drawing from the period), Napoleon persisted in the belief that he would become Emperor of the Orient.

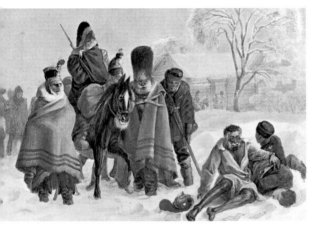

■ Wilhelm von Faber du Faur, one of Napoleon's officers in Russia, illustrated the retreat of the Grande Armée in this drawing. Snow and ice caused the death of thousands of soldiers, defeated by cold and hunger.

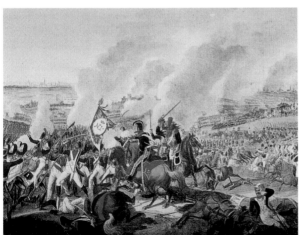

■ Carl Heinrich Rahl, *The Battle of Leipzig*, 1813. After the "Battle of the Nations" at Leipzig, all the member states of the Rhine Confederation, founded by Napoleon in 1806, decided to dissolve the pact that bound them to the French emperor.

LIFE AND WORKS

Hermann's Tomb

Like the Napoleonic soldiers adrift in the Russian snow, the French soldier in Friedrich's *The "Chasseur" in the Woods* wanders alone and lost in a German forest, and the crow on the tree trunk in the foreground – a touch borrowed from Flemish painting – sings him a funerary song and intimates his death. In *Hermann's Tomb*, the same soldier comes upon the open casket of Hermann, the Germanic hero who scored a victory against the Romans in the first century AD. In the 1820s, patriotic and anti-Napoleonic feelings intensified throughout Europe. In Dresden, Friedrich moved in intellectual circles that upheld strong national ideals and were liberal and republican by inclination. One of the most popular and widely read plays within these circles was Heinrich von Kleist's *Hermannsschlacht* (The Battle of Hermann), through which the playwright incited his contemporaries to rise up and fight the foreign invader (Napoleon), just as Hermann had fought against the Roman army.

■ Pieter Bruegel, *The Return of the Herd*, 1565, Kunsthistorisches Museum, Vienna. The crow perching on the branch on the top left-hand side of the painting is a symbol of ill fortune and death. Friedrich employs the device in his *"Chasseur" in the Woods*.

■ Friedrich, *The "Chasseur" in the Woods*, 1814, Private Collection, Bielefeld.

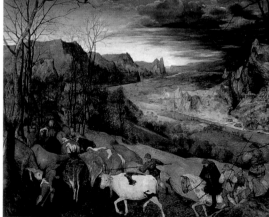

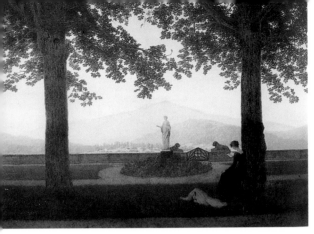

■ Friedrich, *Garden Terrace*, 1811–12, Stiftung Schlösser und Gärten, Potsdam–Sanssouci. Beyond the wall of this French-style garden is a gentle, dreamlike landscape, a vision of happiness and a freedom to come.

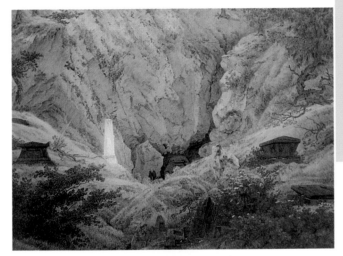

■ Friedrich, *Graves of Ancient Heroes*, 1812, Kunsthalle, Hamburg. The white obelisk beside the entrance to the cave bears the following inscription: "Young savior of the homeland." The painting comes to symbolize freedom in general and freedom from the Napoleonic yoke in particular.

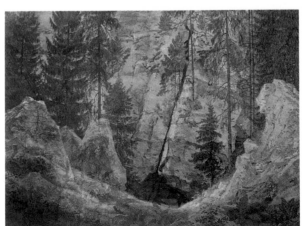

■ Friedrich, *Hermann's Tomb (Pine Forest with Crow)*, 1813–14, Kunsthalle, Bremen. This is one of three paintings that Friedrich exhibited in March 1814 at a show of patriotic works held in Dresden after liberation from the French.

Friedrich, *Swans in the Rushes*, 1819–20, Freies Deutsches Hochstift, Frankfurt

Maturity

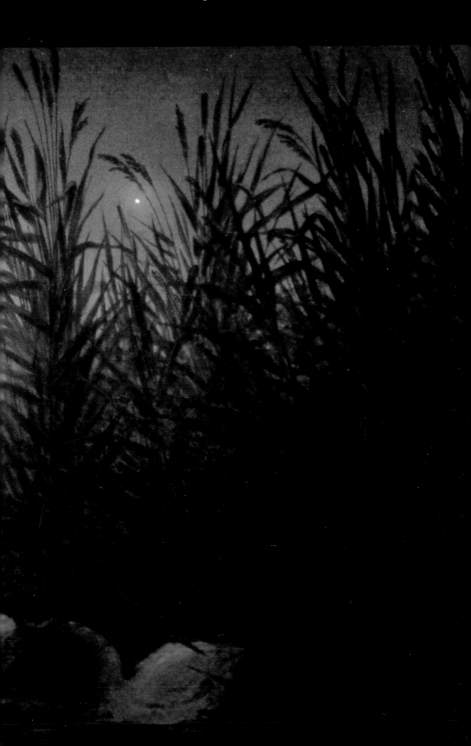

The Congress of Vienna

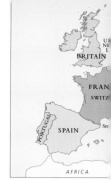

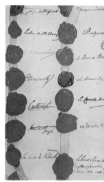

After Napoleon's defeat at the Battle of Waterloo, negotiations began that led to the Congress of Vienna. The Congress lasted from the autumn of 1814 until the summer of 1815 and taking part in the debates were the sovereigns and the chief ministers of all the European powers. Austria, Great Britain, Russia, Prussia, and France took pride of place and the most influential figures included Charles-Maurice Talleyrand-Périgord, the representative of the French Bourbons, and Prince Metternich, Chancellor of the Hapsburg Austrian Empire. One of the major objectives of the Vienna discussions was to restore order to France and, above all, to redraw the boundaries around French territory: all Napoleon's annexations were annulled and the demarcation lines of the Bourbon kingdom restored to what they had been in 1782. Another important consequence of the Congress was the setting up of the Holy Alliance, instigated by Russia. The treaty, in the name of the "Most Holy and Indivisible Trinity" was underwritten by Tsar Alexander I, Emperor Francis I of Austria, and King Frederick William III of Prussia, who committed themselves to unity and mutual assistance. The old continent regained its lost stability. Louis XVIII was returned to the French throne and all the European countries found their rightful sovereigns once again.

■ Shown here is the official Congress of Vienna agreement, drawn up on June 9, 1815, signed and sealed by all those who took part in it.

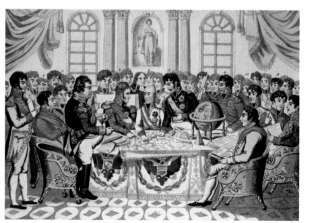

■ Left: a sitting of the Congress of Vienna is captured by the caricaturist Zutz in about 1815 (Kunsthistorisches Museum, Vienna).

■ Right: Sir Thomas Lawrence, *Portrait of the Statesman Klemens Wenzel Lothar, Prince von Metternich*, c.1815. Metternich died in Vienna on June 11, 1859.

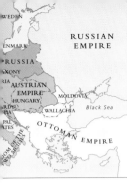

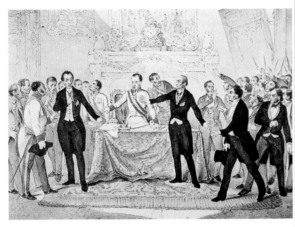

■ The map of Europe was redrawn after the Congress of Vienna.

■ Popular insurrections erupted in Vienna in March 1848 in protest against the restoration of Metternich's government, forcing the Chancellor to resign (as shown on the right) and flee abroad.

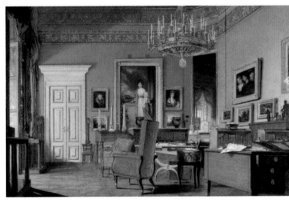

■ *Prince Metternich's Study*, 1829, Historisches Museum, Vienna. Metternich remained in Vienna until 1801, the year in which he was sent to Dresden as imperial ambassador. He returned to Vienna when he was appointed foreign minister.

Chancellor Metternich

Born in Koblenz in 1773 into a family of diplomats, Klemens Wenzel Metternich studied law in Strasbourg and Mainz before moving to Vienna in 1794. After serving as the Austrian emperor's ambassador to Dresden, Berlin, and Paris, he was appointed foreign minister and then Chancellor in 1821. He vigorously defended his policy of restoring monarchic power, declaring himself to be firmly opposed to all liberal tendencies. However, when the revolution of March 1848 broke out in Vienna, he was forced to resign from the Austrian government.

Figures with unknown faces

Their gaze directed towards the infinite and the unknown, Friedrich's figures almost always have their back to us and never look at the viewer. Are they symbols of the unbridgeable gap between man and nature or, conversely, of their profound union? An expression of the tragedy of a life spent away from nature or an image of the fusion between man and the world around him? Friedrich's Romantic spirit led him to believe in the possibility of bridging the void between man and nature through the conciliatory power of the universe. The figure in *The Wanderer Before the Sea of Fog*, engrossed in his contemplation of the vastness of the landscape, seems to be aware of his own inadequacy: he is essentially a spectator. Friedrich often emphasizes the smallness of man before the infinity of nature by rendering the figures in reduced dimensions, making them symbols of the individual's deep sense of solitude and quest for a harmonious union with God. The viewer can easily identify with these mysterious figures, himself becoming the protagonist of the painting and projecting his own inner feelings onto Friedrich's spiritual and symbolic landscapes.

■ Below: Friedrich, *The Wanderer before the Sea of Fog*, 1818, Kunsthalle, Hamburg. The fog enveloping the rocky landscape below intensifies the mysterious, disturbing quality of the painting.

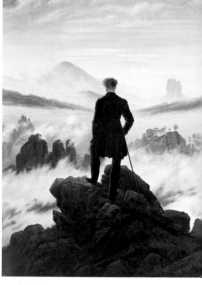

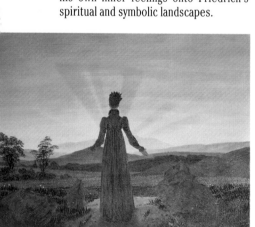

■ Friedrich, *Woman Before the Sunset*, 1818, Museum Folkwang, Essen. The woman views the sunset with open arms, as if she wishes to be more than a mere spectator and to participate actively in the natural phenomenon of the setting sun.

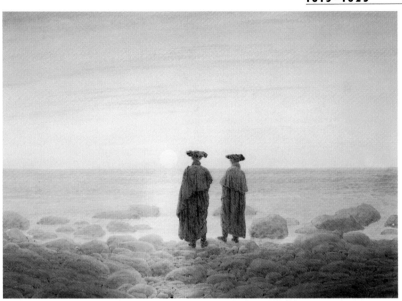

■ Friedrich, *Two Men on the Seashore at Moonrise*, 1835, State Hermitage Museum, St Petersburg. Even in his final paintings, Friedrich painted his figures from behind, a device he first employed in 1816–17.

■ Friedrich, *Landscape with Male Figure*, 1837–38, Pushkin Museum, Moscow. Unlike many other landscape artists, whose figures animate the painting and blend into the surrounding landscape, Friedrich's figures are never at one with nature but are clearly separated from it.

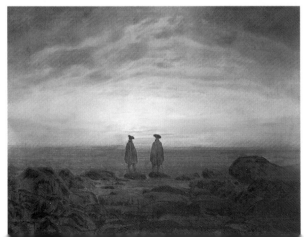

■ Friedrich, *Two Men by the Seashore at Moonrise*, 1817, Nationalgalerie, Berlin. Some art lovers of the time were critical of the reflections of the moon on the water, considering them to be too pale.

Greifswald in Moonlight

Painted between 1816 and 1817, this work shows
Greifswald, Friedrich's native city, with its
spires disappearing into the background like a
distant, hazy vision. The painting is currently
housed in Oslo's Nasjonalgalleriet.

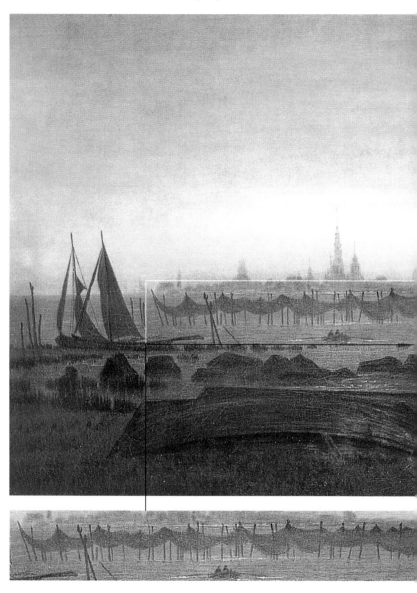

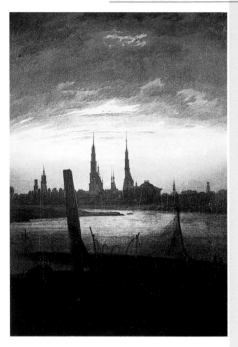

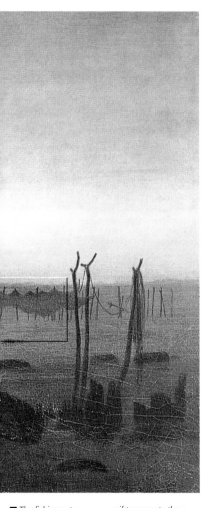

■ Above: Friedrich, *City in the Moonlight*, c.1817, Stiftung Oskar Reinhart, Winterthur. This painting also includes a barrier in the foreground, in this case the fishing nets hanging out to dry.

■ Below: Friedrich, *Coastal Landscape in the Evening*, c.1816–18, Museum für Kunst und Kulturgeschichte, Lübeck. Two fishermen return home after a day at sea.

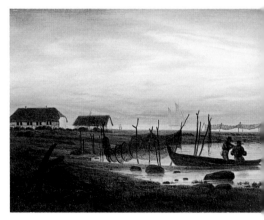

■ The fishing nets form a horizontal barrier in the center of the painting, dividing the foreground from the background, almost as if to separate the present from the future and to symbolize the boundary between heaven and earth.

The Friedrich family

T o the surprise of his friends, in January 1818, at the age of 44, Friedrich decided to marry the 25-year-old Christiane Caroline Bommer. He had met her only a few months before, possibly through his friend Kersting, a relative of the bride. Letters written by "Line", as Friedrich affectionately called her, suggest that she was lively and kind, always willing to help those around her and to cheer them up with her joyful personality. Such character traits were in sharp contrast to the melancholy Friedrich, who was so often engrossed in his own dark thoughts. The marriage was a happy one. As Friedrich wrote: "Much has changed since 'I' became 'we'. My old, simple house is almost unrecognizable and I am so glad that everything is so clean and welcoming." Immediately after the wedding, the artist and his young wife travelled to Pomerania to visit relatives and friends, who had only learned of the marriage a week earlier – further illustration of Friedrich's shy, reserved nature. Their first child, Emma, was born the following year, followed by Agnes Adelheid in 1823 and Gustav Adolf in 1824.

■ Friedrich, Study for the painting *On the Sailing Ship*, 1818, Nasjonalgalleriet, Oslo. Immediately after the couple's honeymoon in Pomerania, Friedrich began work on preparatory studies for this painting, in which he appears with Caroline.

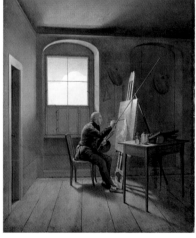

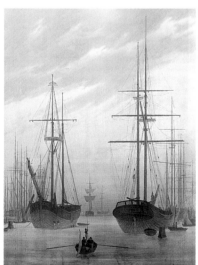

■ Friedrich, *View of a Harbor*, 1816, Stiftung Schlösser und Gärten, Potsdam-Sanssouci. Here, the harbor becomes a symbol of the divine origin of life.

■ Georg Friedrich Kersting, *Caspar David Friedrich in his Studio*, 1811, Kunsthalle, Hamburg. Friedrich's studio was bare and sparsely furnished.

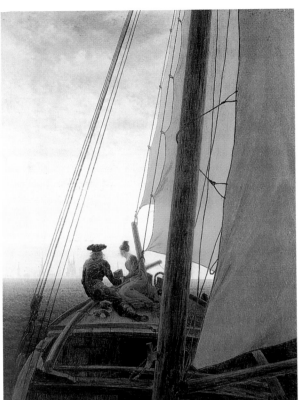

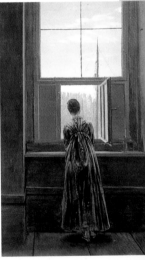

■ Friedrich, *On the Sailing Ship* 1818–19, State Hermitage Museum, St Petersburg. Here, Friedrich and his wife setting out on their journey to happiness. This painting was bought by Tsar Nicholas I.

■ Friedrich, *Woman at the Window*, 1822, Nationalgalerie, Berlin. Friedrich observes the world through the eyes of his wife Caroline, who looks out of the window of their house on the River Elbe.

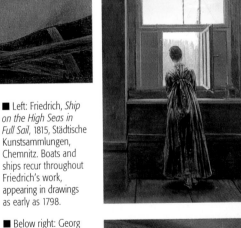

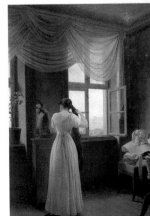

■ Left: Friedrich, *Ship on the High Seas in Full Sail*, 1815, Städtische Kunstsammlungen, Chemnitz. Boats and ships recur throughout Friedrich's work, appearing in drawings as early as 1798.

■ Below right: Georg Friedrich Kersting, *In Front of the Mirror*, 1827, Kunsthalle, Kiel. The affinity with Friedrich's style is clear. Kersting may well have seen Friedrich's *Woman at the Window* during one of his many visits to the artist's studio.

BACKGROUND

Carl-Gustav Carus

A great friend of Friedrich's, Carl-Gustav Carus (1789–1869) was not only a landscape artist, but also a philosopher, scientist, and doctor, who was appointed personal physician to the King of Saxony. Carus and Friedrich met in Dresden in 1817 and at once became firm friends, drawn together in particular by their common approach to art. Both saw it as a means of drawing closer to nature, which they perceived as a divine mediator and an instrument through which to communicate with God. "Natural beauty is more divine and artistic beauty more human," wrote Carus in his *Nine Letters on Landscape Painting*, published in 1831. To the objective observation of natural phenomena Carus added a transfiguration of reality derived from feelings aroused by the contemplation of nature. Unlike Friedrich, however, he strikes a less spiritual and metaphysical note in his paintings, which are essentially sentimental interpretations of landscape. The dense fog on the landscape, the boats, and the sailing ships, are all elements borrowed from Friedrich's iconographic repertoire. The two artists were friends for many years, despite the differences in their personalities: Friedrich was retiring, almost misanthropic, and Carus extrovert and gregarious.

■ Below: Carl-Gustav Carus, *The Sea of Ice near Chamonix*, 1825–27, Georg Schäfer Collection, Schweinfurt. This painting is like an illustration to a scientific publication on glaciers.

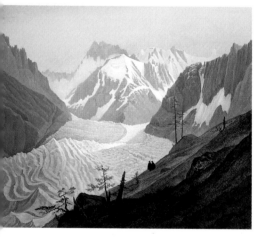

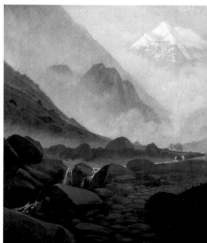

■ Right: Carl-Gustav Carus, *Valley in the High Mountains*, 1822, Kunstmuseum, Düsseldorf. As in so many of Friedrich's paintings, Carus also uses fog to create a mysterious effect, blurring the picture of the mountains that emerge in the distance, with only their snowy peaks visible.

■ Below: Carl-Gustav Carus, *Woman on the Terrace*, 1824, Gemäldegalerie, Dresden. Here, Carus depicts a woman gazing out at a distant landscape. A similar figure often appears in paintings produced by Friedrich between 1815 and 1820.

■ Carl-Gustav Carus, *Monument to Goethe* 1832, Kunsthalle, Hamburg. Carus painted this work just after Goethe's death on March 22, 1832. The artist met the great German writer and philosopher in the early 1820s.

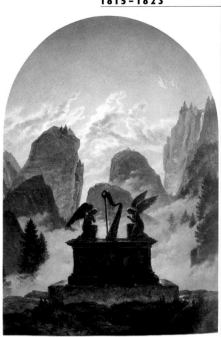

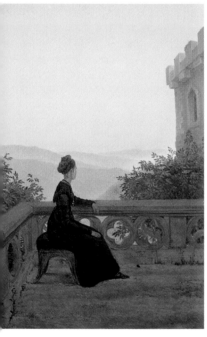

■ Right: Carl-Gustav Carus, *Boat Trip on the Elbe* 1827, Kunstmuseum, Düsseldorf. Unlike the couple in Friedrich's *On the Sailing Ship*, these two figures are not gazing out at the city together. Here, the woman watches the man rowing.

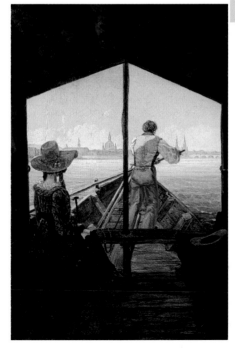

The Cliffs at Rügen

Painted in about 1818, this work (Oskar Reinhart Stiftung, Winterthur) was based on drawings Friedrich made while on his honeymoon in Rügen. The exact spot shown in the work has never been identified and it is likely that the artist combined several different locations.

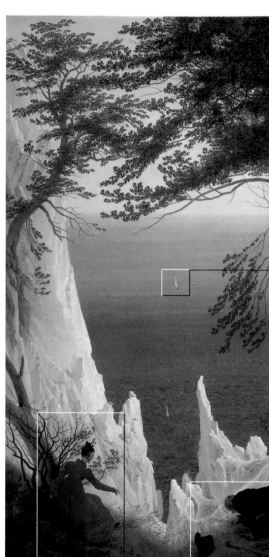

■ The figure of the woman, who grasps the branch of a bush to stop herself from sliding down the precipice, is the artist's wife, Caroline. Her red gown may be intended to symbolize Christian love and charity.

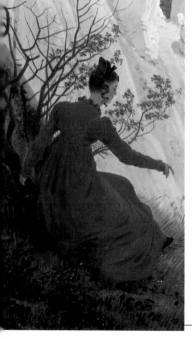

■ The boat sailing across the Baltic Sea towards unknown destinations could, according to Friedrich's usual symbolism, be interpreted as the vessel leading man across the sea to eternity, from life on earth to life in heaven. The boat becomes a symbol of the long journey man has to make in order to inherit the kingdom of God.

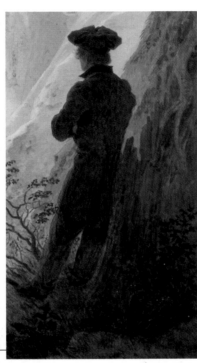

■ The man, who wears traditional German dress, has often been identified as the artist's brother, Christian, but the figure could also be a self-portrait. Engrossed in his contemplation of the marine landscape, this figure has been interpreted as an allegorical figure of hope.

■ The old man has laid down his hat and cane in order to rummage on all fours through the blades of grass near the edge of the precipice, a stance denoting a certain resignation and humility. The blue of his clothing symbolizes Christian faith.

The theme of death

The crows flying slowly around the gigantic oak tree are the dark harbingers of death, an illusion emphasized by the fiery colors of the sky and the gnarled tree trunks in the foreground. The branches are dry and the wood appears to be rotten. Death is a recurring theme in Friedrich's paintings and can be found in his earliest works, in which Gothic ruins, disinterred graves, crosses, and funeral cortèges appear in snowy landscapes. The young Friedrich experienced death at close hand early in his life, first when his mother died and later with the premature demise of his siblings, Elisabeth, Maria, and Johann Christopher. In a sepia drawing he made at the age of 30, Friedrich even went so far as to envisage his own funeral, having attempted suicide a few years earlier. Indeed, the paintings onto which he projected his own inner feelings could not fail to refer to these tragic events. The portals of ruined abbeys become a symbol of death, the gates to the eternal life beyond. Life on earth is no more than waiting for death, since only death can give meaning to life. The wizened branches of the trees, the dead leaves, and the steep slopes are not only symbols of the transitory nature of life, but also of the hope that death will mark the transition from life on earth to life in heaven.

■ Right: Friedrich, *The Woman with the Cobweb*, c.1803. Kunsthalle, Hamburg. Friedrich's drawing – of which his brother made a woodcut – has been compared with Dürer's *Melencholia* and is also known as *Melancholy*. The cobweb symbolizes the transience of beauty and art.

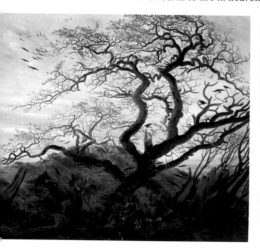

■ Left: Friedrich, *The Crows' Tree*, 1822, Musée du Louvre, Paris. The old oak tree and its arched branches becomes a metaphor for death.

■ Above: Vincent van Gogh, *Crows in the Wheatfields*, 1890, Van Gogh Museum, Amsterdam. Van Gogh would also take up the theme of the crow as the harbinger of death.

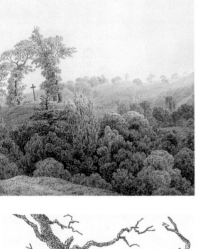

■ Left: Friedrich, *Coastal Landscape with Cross and Statue*, c.1835 Kupferstichkabinett, Berlin. The two tree tops form an arch similar to the portal leading into a Gothic cathedral, a doorway to eternal life.

■ Friedrich, *Coffin by the Graveside*, 1836, Pushkin Museum, Moscow. This work, which captures the moment before the coffin is lowered into the grave, almost seems to herald the artist's own death four years later.

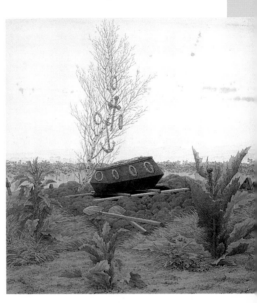

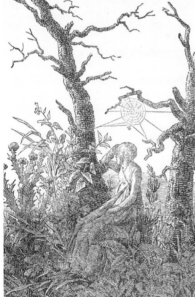

■ Right: Friedrich, *Owl on a Grave*, 1836–37, Pushkin Museum, Moscow. The owl, a personification of the night and, by extension, of death, frequently appears in Friedrich's later works.

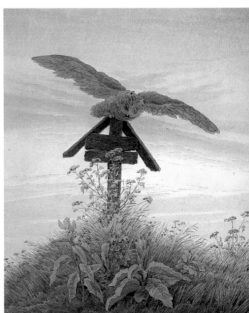

From Homer to Shakespeare

In about 1800, a cult extolling the virtues of a primitive and unsullied world arose throughout Europe. Artists and writers dreamed of a return to their origins and a rejection of the illusionistic techniques developed throughout the 16th, 17th, and 18th centuries. The popularity of primordial civilizations led artists to look to the most ancient masterpieces of classical mythology for their inspiration and to cultivate extreme formal purity in their painting. Aeschylus, Hesiod, and Homer were the favorite classical writers of Fuseli, Blake, and Flaxman, who also admired Dante, Milton, and Ossian. Works by these artists do not reflect the harmony and classical coherence advocated by Johann Joachim Winckelmann in the mid-18th century, but expressed an obscure, almost barbaric notion of antiquity. Greek and Roman literature became the source of inspiration for the dramatic images charged with tension and emotion that were pursued by artists fascinated by the fantastic and sublime. Ulysses confronting Scylla and Clytemnaestra plunging the dagger into Agamemnon's chest were scenes of danger and horror that had a powerful impact on the viewer. Artists moved away from the intellect in order to embrace deep emotion, imagination, dream, and myth.

■ Giuseppe Sabatelli, *Othello and Desdemona*, 1834, Pinacoteca di Brera, Milan. In keeping with the Romantic tendencies of the day, this artist chose a Shakespearean subject for his work.

■ Below: Henry Fuseli, *Crimhilde Sees the Dead Siegfried in a Dream*, 1805–10, Private Collection, Zürich. The Germanic saga of the "Nibelungen" fascinated artists because of the remote and longed-for civilization it depictions.

■ Above: Henry Fuseli *Ulysses Between Scylla and Carybdis*, 1794–96, Aargauer Kunsthaus, Aaargau. The three heads of the monster devouring Ulysses's companions can be seen at the top of the painting.

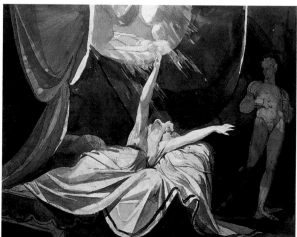

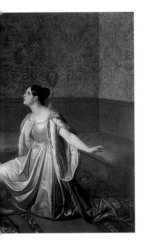

■ Jean-Auguste-Dominique Ingres, *The Dream of Ossian*, 1813, Musée Ingres, Montauban. Here, Ingres creates a fantastical and visionary image inspired by the myth of Ossian. From the first half of the 18th century a veritable psychological revolution erupted, as dreams and the unconscious became the focus of much interest.

■ Right: François Gérard, *Ossian Conjures up Ghosts to the Sound of the Harp*, 1801, Kunsthalle, Hamburg. This work was commissioned by Napoleon.

■ Below: William Blake, *Antheus Setting Dante and Virgil on the Ground*, 1824, National Gallery, Melbourne. Blake's work, Dantesque in derivation, places the powerful figure of Antheus at the center.

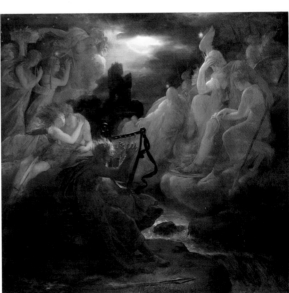

The myth of Ossian

The poems of Ossian, allegedly translations of ancient Gaelic manuscripts but in fact written by the Scottish poet James Macpherson between 1762 and 1763, aroused much enthusiasm and enjoyed huge success. Ossian was the fictitious hero of these legendary poems, a Gaelic bard and mythical warrior. Runge, Carstens, Fuseli, Abildgaard, and many other artists were inspired by the cycle of epic poems and drew on them to produce dreamlike, fantastical images. Even Napoleon was bitten by the Ossianic cult, and spread the myth by commissioning a number of paintings on the subject for his residences.

LIFE AND WORKS

Johan Christian Clausen Dahl

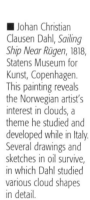

B y the time the Norwegian painter Johan Christian Clausen Dahl had moved into Friedrich's home in 1823 the two artists had known one another for almost five years, Dahl having moved from Copenhagen to Dresden in 1818. Like Friedrich before him, Dahl attended the Academy of Fine Arts in the Danish capital, and his early training was influenced by the Dutch and Flemish landscape artists of the 17th century, particularly Van Everdingen. When he arrived in Dresden, his works were already enjoying a moderate success and his popularity soon spread throughout the German territory. Unlike Friedrich, the Norwegian artists could not resist the lure of Italy and, in 1820, the day after his wedding to Emilie von Block, Dahl set off on the Grand Tour. He visited Capri, Naples, and Rome, where he was part of the circle of northern artists who gathered at the Villa Malta. The themes of his heroic landscapes, although far removed from Friedrich's spiritual images, occasionally reveal something of Friedrich's influence – *Megalithic Grave in Winter,* for example, which includes oak trees and ships. The artists remained neighbors for almost 20 years, until Friedrich's death in 1840.

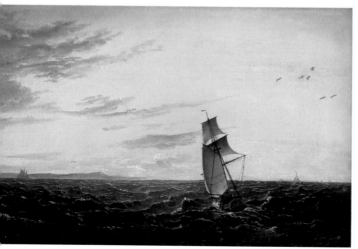

■ Johan Christian Clausen Dahl, *Sailing Ship Near Rügen*, 1818, Statens Museum for Kunst, Copenhagen. This painting reveals the Norwegian artist's interest in clouds, a theme he studied and developed while in Italy. Several drawings and sketches in oil survive, in which Dahl studied various cloud shapes in detail.

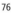

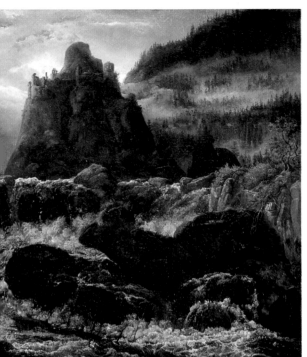

■ Johan Christian Clausen Dahl, *Landscape with Castle, Waterfalls, and Ruins*, 1819, Billedgallery Rasmus Meyers Samlinger N., Bergen. Under a menacing sky, a ruined castle rises up in a fog-bound landscape. This is an imaginary scene, which echoes the verses of the ancient Nordic poets.

■ Below: Johan Christian Clausen Dahl, *Italian Landscape*, 1818, Nasjonalgalleriet, Oslo. Dahl went to Italy at the invitation of the Danish Crown Prince Christian Frederick, who welcomed him in his villa at Quisisana, near Castellammare di Stabia.

■ Left: Johan Christian Clausen Dahl, *Study for a Birch Tree*, 1826, Nasjonalgalleriet, Oslo. After a brief sojourn in Italy (1820–21), Dahl settled in Dresden and painted mainly scenes inspired by the Norwegian landscape, placing particular emphasis on luminosity.

Schinkel, von Klenze, and the return to antiquity

During the late 18th century and the first half of the 19th century, the appeal of ancient, unsullied civilizations also began to influence architecture. The essential, pure outlines of Doric temples from ancient Greece – the mythical and idealized symbol of the past – were recreated by German architects Karl Friedrich Schinkel and Leo von Klenze in the design of their majestic neoclassical German museums (the Altes Museum in Berlin and the Glyptothek in Munich), ideal buildings in which to house the treasures of a long-lost world. Schinkel even attempted to revive the classical past by rebuilding a palace on the Acropolis in Athens, commissioned by Otto of Bavaria, who had become King of Greece. Von Klenze, on the other hand, built the Walhalla, an enormous temple on the Danube near Regensburg, in celebration of German greatness.

The buildings and designs created by these two architects reflected their visionary quest for the classical architecture of a lost civilization.

■ Below: Karl Friedrich Schinkel, *Entrance to the Palace of the Queen of the Night*, stage design for a production of Mozart's *The Magic Flute* at the Berliner Schauspielhaus in 1816.

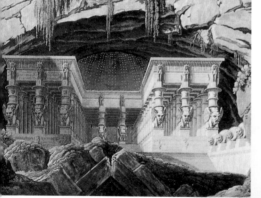

■ Right: Karl Friedrich Schinkel, *Gothic Church on a Rock by the Sea*, c.1813, Neue Pinakothek, Munich. Schinkel reveals a particular fondness for Gothic architecture in his paintings.

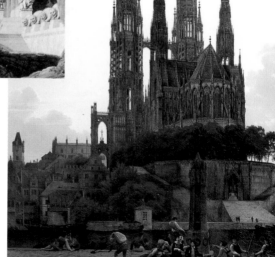

■ Left: *Portrait of Georg Friedrich Wilhelm Hegel*, 19th century, Private Collection. The grandiose designs of Schinkel and von Klenze embodied Hegel's notion of the sublime.

■ Right: Karl Friedrich Schinkel, design for a palace, 1838. This project was for a castle on the Black Sea, intended for the Russian empress.

■ Left: Karl Friedrich Schinkel, design for the grand hall of a royal palace on the Acropolis at Athens, 1834, Staatliche Schlösser und Gärten, Berlin. A pupil of Friedrich Gilly's, Schinkel was appointed superintendent of building works for Berlin in 1815, and for the whole of Prussia in 1838.

■ Leo von Klenze, design for the Glyptothek in Grecian style, 1815, Munich. As court architect to the prince, later King Louis I of Bavaria, von Klenze was responsible for the rebuilding of Munich in the neoclassical style.

■ Below right: Leo von Klenze, design for the Glyptothek in the Palladian style, 1815, Munich. Von Klenze was in St Petersburg from 1830 to 1842, working on the new wing of the Hermitage Palace.

Two Men Contemplating the Moon

A note written by Dahl tells us that Friedrich worked on this painting, now in Dresden's Gemäldegalerie, in 1819. It is likely to be a self-portrait of the artist, shown with his pupil August Heinrich.

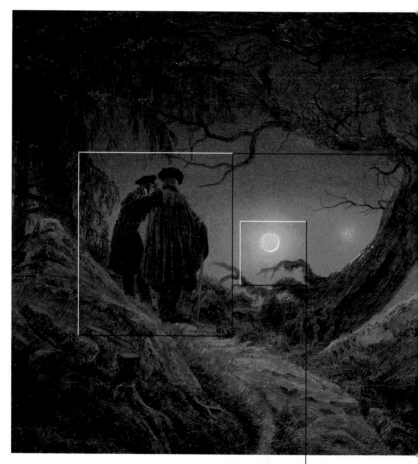

■ The pale moonlight, symbol of the Romantic yearning for the life beyond, bathes the landscape and ensures that the individual elements of nature are not too sharply outlined but blend into a harmonious whole. Friedrich was particularly fascinated by moonscapes and even believed that man, once reborn, might find himself on the moon.

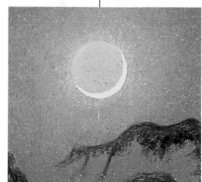

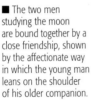

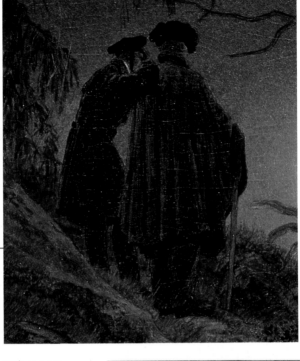

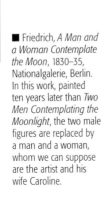

■ The two men
studying the moon
are bound together by a
close friendship, shown
by the affectionate way
in which the young man
leans on the shoulder
of his older companion.

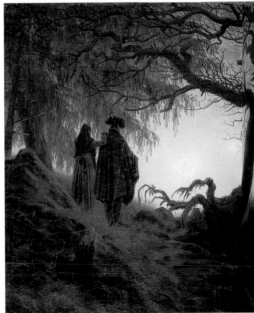

■ Friedrich, *A Man and
a Woman Contemplate
the Moon*, 1830–35,
Nationalgalerie, Berlin.
In this work, painted
ten years later than *Two
Men Contemplating the
Moonlight*, the two male
figures are replaced by
a man and a woman,
whom we can suppose
are the artist and his
wife Caroline.

81

Neo-Gothic architecture

The recurring presence of Gothic churches and ruins in the paintings of Friedrich and many other 19th-century artists was known as historicism and was part of a wider phenomenon of the Romantic movement that spread throughout Europe. Architectural features from the past were revived and reworked, sowing the seeds of a revival of national culture. The Middle Ages in particular, being the quintessential period for the development of a national identity and the period during which the Christian faith experienced its widest diffusion, constituted an important source from which artists and architects could draw. For Friedrich, neo-Gothic architecture became a symbol of hope for a new religious and political era. In his paintings, neo-Gothic cathedrals stand majestically in the distance, unattainable dreamlike visions. The two women in *Two Sisters on the Terrace Overlooking the Harbor* appear to be admiring an unreal landscape. In *Cross in the Forest* the spires of the Marienkirche in Neubrandenburg shimmer gently in the background, a mirage among the fir trees. It is as if Friedrich were trying to show us a destination to which we should aspire, without revealing to us the road whereby we can reach it.

■ Friedrich, *Two Sisters on the Terrace Overlooking the Harbor*, c.1820, State Hermitage Museum, St Petersburg. The two women looking out over an almost surreal city have been identified as the artist's wife and sister-in-law, the wife of Friedrich's brother Heinrich. The painting was exhibited in Dresden in 1820, together with four other works.

■ Friedrich, design for an altar with an aedicule in the neo-Gothic style, 1817, Germanisches Nationalmuseum, Nuremberg. This watercolor drawing is part of a project Friedrich worked on for the altar of the Marienkirche at Stralsund, a small town near Rügen.

■ Friedrich, *Owl in a Gothic Window*, 1836, State Hermitage Museum, St Petersburg. The bell-towers of Gothic cathedrals are here replaced by a simple window, which provides this owl with a refuge. The owl, a personification of the night, is a motif that recurs throughout Friedrich's later works.

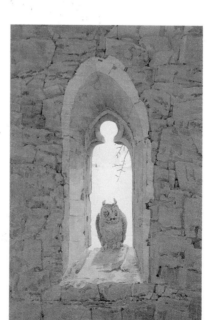

■ Right: Carl Blechen, *Ruins of a Gothic Church*, 1829, Kunstmuseum, Düsseldorf. Blechen's imaginary views are often dominated by Gothic churches and cloisters that are the dwelling-place of hermits and phantoms. His works are devoid of Friedrich's intense religious feelings.

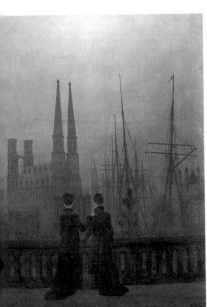

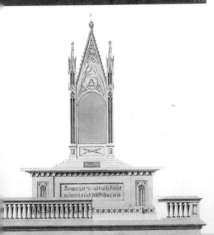

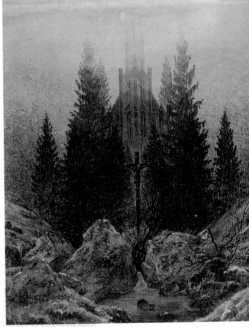

■ Above: Friedrich, *The Cross in the Forest*, 1812, Kunstmuseum, Düsseldorf.

The music of Beethoven and Chopin

During the early Romantic period, Italian music continued to be the most popular choice at the courts of Vienna, Berlin, Munich, and Dresden and it was only in the first decades of the 19th century, within the wider context of a resurgence of national feeling, that musical works in the German language began to be successful. The premiere of *Der Freischütz* by Carl Maria von Weber took place on June 18, 1821 in Berlin, marking the beginning of the German operatic tradition. The symphonies of Schubert and Beethoven's sonatas were also very popular among music lovers both in Vienna and in Prussia, while in France Chopin added a distinct French mood to the German Romantic spirit in his piano music. In Italy, theaters resounded with the music of Gioacchino Rossini and Gaetano Donizetti. Birdsong, the violent peal of thunder, and the fluttering of quails' wings can all be heard in Beethoven's Sixth Symphony (known as the *Pastoral)*, and are the expression of a supreme Romantic sensibility. This same feeling would later pervade the music of Schumann and Liszt, and culminate in the work of Wagner.

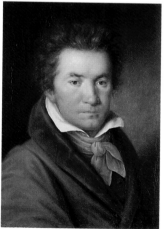

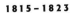
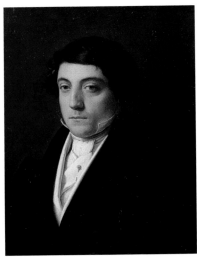

■ Below: Gustav Leybold, *Ludwig van Beethoven's Studio in the Schwarzspanierhaus, in Vienna IX*, Historisches Museum, Vienna (engraving after a drawing by Nepomuk Höchle). Beethoven first went to Vienna in 1787 to study under Wolfgang Amadeus Mozart. He subsequently became a pupil of Mozart's rival, Antonio Salieri.

■ Below: in this painting by Joseph Danhäuser Franz Liszt is shown at the piano surrounded (from left to right) by his friends Berlioz, George Sand, Paganini, and Rossini. A child prodigy, Liszt was only nine years old when he became a pupil of Czerny and Salieri in Vienna, where he also had the honor of playing the piano for Beethoven.

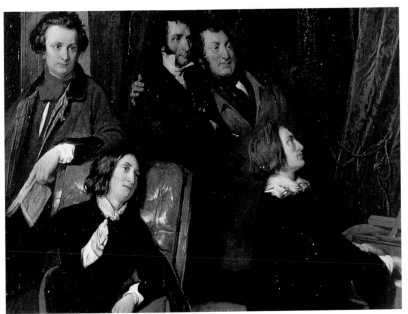

Friedrich and Turner

Turner's paintings are suffused with light, their outlines dissolving into a series of colored reflections. Sky, water, and landscape blend into one another through translucent layers of color, nature becoming an expression of the artist's inner feeling, just as in Friedrich's work. Both artists pursue an ideal dimension within nature, which becomes an unattainable place for man, who is reduced to a minuscule, insignificant dot. The balance between man and nature is torn asunder and man's feeble efforts when faced with the hostility of nature are overwhelmed by the power of the elements. Although similar in their Romantic concept of nature and their aim to describe man's relationship with the world, the two artists employed different expressive means. Friedrich uses light in a traditional way and then invests it with spiritual meaning, whereas Turner uses luminous effects in order to transform and dissolve matter. Friedrich's representation of nature is realistic, whereas Turner's world becomes a fantastic dream in which vision is paramount and supersedes the reality of natural phenomena.

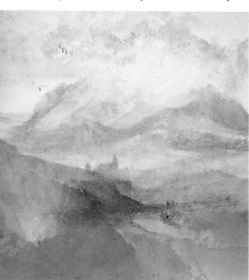

■ Left: Joseph Mallord William Turner, *View of a Mountain Valley*, Private Collection. In this watercolor, possibly of the Val d'Aosta in Italy, light seeps around the landscape until it breaks up its outlines. The work, probably painted on the artist's visit to Italy in 1819, clearly shows how Turner increasingly distanced himself from an objective representation of nature.

■ Joseph Mallord William Turner, *Light and Colour (Goethe's Theory): the Morning after the Deluge*, c.1843, Tate Gallery, London. Goethe based his theory of color not on the optical spectrum like Newton but on a chromatic circle containing positive colors (red, yellow, green) and negative colors (blue). Positive colors express joy, negative ones pain.

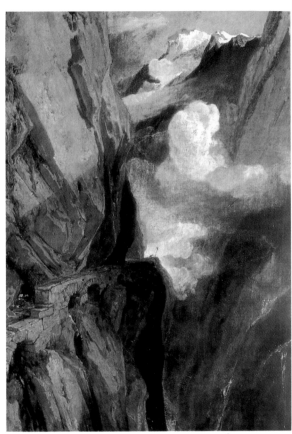

■ Friedrich, *Landscape in the Riesengebirge with the Fog Rising*, 1820, Neue Pinakothek, Munich. A comparison with Turner's *View of a Mountain Valley* (opposite) reveals the affinities between the two artists in their approach to landscape.

■ Above: Joseph Mallord William Turner, *The Pass of St Gotthard*, 1803–04, Museum and Art Gallery, Birmingham. This work shows how the artist began his career by portraying nature in a realistic way.

BACKGROUND

The Biedermeier years

■ This vase with lid, decorated in enamel on a white ground, illustrates the bourgeois preference for bright colors during the Biedermeier years.

From the 1820s onwards, exhausted by years of war and political upheavals and now reassured by the decisions that came out of the Congress of Vienna, the German bourgeoisie withdrew increasingly from political life in order to re-affirm the importance of traditional values. Notions such as family and religion became important once again, leading to a conservative trend in politics, culture, and private life (the name *Biedermeier* denotes the conventional nature of the German bourgeoisie, and derives from the character of Gottfried Biedermeier, an unsophisticated imaginary poet whose verses, actually composed by a number of writers, were published in a German periodical). The bourgeoisie's greatest ambition was for a tranquil home life and lucrative commercial and industrial activity. Passions and powerful emotions were avoided as much as possible, condemned as destructive influences on man's inner harmony. Artists, besides painting landscapes, favored domestic scenes that captured happy moments of bourgeois and peasant family life, executed with minute attention to detail. Meanwhile, writers extolled the virtues of concentrating on the more private aspects of life.

■ Below: Jean Henri Marlet evokes an evening dance during the Biedermeier years. The fashion of the day was for women's gowns to be very tight around the waist, with full sleeves and wide skirts.

■ Piano, c.1820. The elegant lines of this instrument, which could convert to a dressing table, are typical of the furniture made in Vienna during the Biedermeier period.

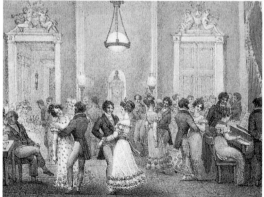

■ Right: Adrian Ludwig Richter, *Genevieve in the Woods*, 1841, Kunsthalle, Hamburg. A long way from civilization, Genevieve and her child look for peace and harmony in the lonely woods.

■ Below left: Friedrich von Amerling, *Rudolf von Arthaber with his Children Rudolf, Emilie, and Gustav Admiring a Portrait of their Deceased Mother*, 1837, Österreichische Galerie, Vienna.

■ Below right: Carl Spitzweg, *The Impoverished Poet*, 1839, Neue Pinakothek, Munich. The artist may have been inspired by the 18th-century poet Matthias Ettenhuber for this painting.

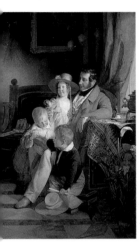

■ Left: Adrian Ludwig Richter, *Spring Evening*, 1844, Kunstmuseum, Düsseldorf. Richter favored small-format paintings and subjects taken from fables and sagas showing children and simple country folk. From 1837 onwards he devoted himself to illustrating fables and travel books.

Meadows in Greifswald

Friedrich depicts his native Greifswald with extreme precision and topographic accuracy in this painting, which he completed in 1820. Today it is housed in Hamburg's Kunsthalle.

■ Windmills are a characteristic sight in the northern landscape. The line formed by the windmills' vanes guides the viewer's eye from the outer part of the painting to the point where the cityscape begins, forming a horizontal line parallel with the line in the foregound, made up of grass-covered ditches. The windmills, together with the spires of the Greifswald churches, are the only vertical elements in the painting, in which horizontal lines dominate.

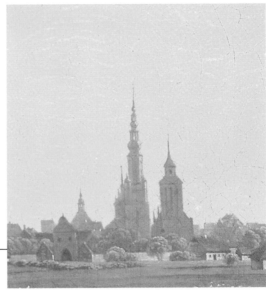

■ Above: the spires standing proudly against the sky are the painting's focal point. They are the bell-tower of the church of St James and the church of St Nicholas respectively. St Nicholas's bell-tower, which is baroque in style, is the highest in the city.

■ Below: the horses running and bucking across the Greifswald meadows enliven the painting and create an atmosphere of harmony and tranquillity, which pervades the entire landscape. Behind them, a pond forms the third horizontal line in the painting: this could be the spot where Friedrich's brother drowned.

"An der Elbe 33"

On August 21, 1820, when his daughter Emma was almost one, Friedrich moved with his family to a house, number 33, on the River Elbe. Friedrich was very fond of the river and liked to watch the boats sailing slowly past his home. Although his modest lifestyle did not suggest it, he had, by this time, become an established and successful artist – since 1810 he had been a member of the Berlin Academy and since 1816 a member of the Dresden Academy. His paintings were much sought-after by collectors who came in droves to admire his work. Friedrich was also visited by many of the most influential figures of his day: besides poets and artists, such as the Nazarene painters Peter von Cornelius and Friedrich Overbeck and the author of *Ondine*, Friedrich de la Motte-Fouqué, Friedrich also welcomed aristocrats and princes into his riverside home. Just before Christmas 1820, the Russian Grand Duke, who would later become Tsar Nicholas I, asked if he might view the German artist's work. The following year, by order of the archduke, the Russian poet Zhukovsky came and purchased many of Friedrich's paintings.

■ Below: "An der Elbe 33"; Friedrich moved to this house in 1820 with his wife and daughter Emma.

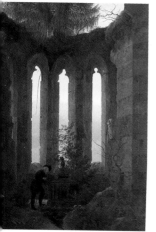

■ Above: Friedrich, *Ulrich von Hutten's Grave*, 1823, Kunstsammlungen, Weimar. The painting commemorates the German hero Ulrich von Hutten.

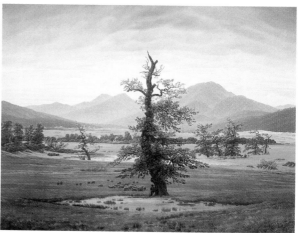

■ Left: engraving by
Carl Christian Vogel
von Vogelstein of
the Russian poet
Wassily Zhukovsky.

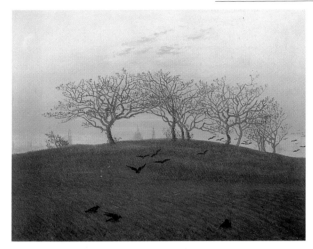

■ Right: Friedrich, *Hill
and Field Near Dresden*,
c.1824, Kunsthalle,
Hamburg. The crow
as a symbol of death
appears once again.
In the distance we can
make out the rooftops
and spires of Dresden.

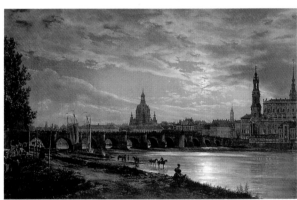

■ Left: Johan Christian
Clausen Dahl, *Dresden
in Moonlight*, 1839,
Gemäldegalerie,
Dresden. Dahl
moved into Friedrich's
house in 1823.

■ Right: Friedrich,
*Gerhard von Kügelgen's
Grave*, 1821–22, Private
Collection. On March
27, 1820, the painter
Gerhard von Kügelgen
was murdered. He had
been a close friend of
Friedrich's since 1805.

■ Left: Friedrich,
*Village Landscape in
the Morning Light*, 1822,
Nationalgalerie, Berlin.

The Nazarenes

■ Letter from Friedrich to Julius Schnorr von Carolsfeld, 1823, Private Collection.

In about 1810, a group of young painters led by artists Friedrich Overbeck and Franz Pforr, moved from Vienna to Rome with the specific intention of bringing about a new religious movement in painting, which would be in direct opposition to the Neoclassical tendency and have as its models the Italian artists of the Quattrocento preceding Raphael. In Vienna, these artists had officially broken away from the Academy and formed the Brotherhood of St Luke, the patron saint of painters. Once in Rome, they immediately sought out the foreign artists and intellectuals who gravitated around the Villa Malta. Koch and Thorvaldsen admired the newcomers' works illustrating the lives of the saints, scenes from the German Middle Ages, and works of literature. Goethe was not so enthusiastic, denouncing the "Nazarene stupidity" of these long-haired, blonde artists. The Nazarenes, however, believed they had been sent to Rome to fulfil a kind of mission, living communally in the convent of St Isidore in Rome and leading an exemplary shared existence based on collective work in the spirit of the ancient craftsmen. Their art, which is literary and cultured in its references to Fra Angelico, Pinturicchio, and Perugino, is rich in moral content and borders on religious propaganda.

■ Friedrich Wilhelm von Schadow, The Holy Family under a Portico, c.1810, Neue Pinakothek, Munich. The image of the Holy Child is taken from 15th-century Italian painting.

■ Julius Schnorr von Carolsfeld, Naval Battle, Casino Massimo, Rome. The Nazarenes, supervised by Overbeck, were joined by Peter von Cornelius, Friedrich Wilhelm von Shadow, and Joseph Führich in working on the frescoes for the Casino Massimo. The decorations are based on Dante's Divine Comedy and the work of Tasso and Ariosto.

■ Friedrich Overbeck, *Italy and Germany*, 1812–28, Neue Pinakothek, Munich. The artist painted this allegory of friendship for his close friend Franz Pforr, whom he met at the Vienna Academy. Tragically, Pforr's untimely death prevented Overbeck from presenting him with the painting.

■ Friedrich Overbeck, *Franz Pforr*, c.1810, Nationalgalerie, Berlin. This is a "friendship portrait", a genre that developed in German art in the early 19th century. The traditional German attire and the Gothic cathedral in the background are typical features of Nazarene art, which often drew upon the Middle Ages for inspiration.

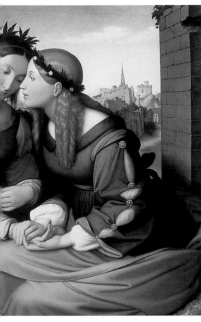

The Casino Massimo

The fresco cycle for the Casino of the marquis Carlo Massimo, begun in 1818, marks both the highest artistic achievement of the Nazarenes and the point at which the group began to break up. The frescoes are a visual expression of Overbeck's ideal of a cultured art inspired by Renaissance models. The project was so difficult, however, and was taking such a long time to complete, that the idea was abandoned by almost all the artists involved. It was only finished in 1830, after 12 years' work.

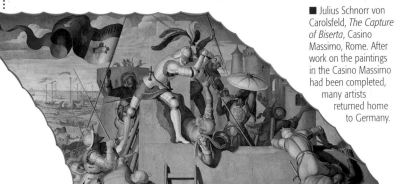

■ Julius Schnorr von Carolsfeld, *The Capture of Biserta*, Casino Massimo, Rome. After work on the paintings in the Casino Massimo had been completed, many artists returned home to Germany.

Moonrise over the Sea

This work was painted in 1822 as a companion piece to *Village Landscape in the Morning Light*, for Consul Wagener, an aristocratic Berlin art collector. After his death, his amassed works passed to the Prussian royal family and subsequently formed the nucleus of the Berlin Nationalgalerie's collection, the museum in which this painting is housed to this day.

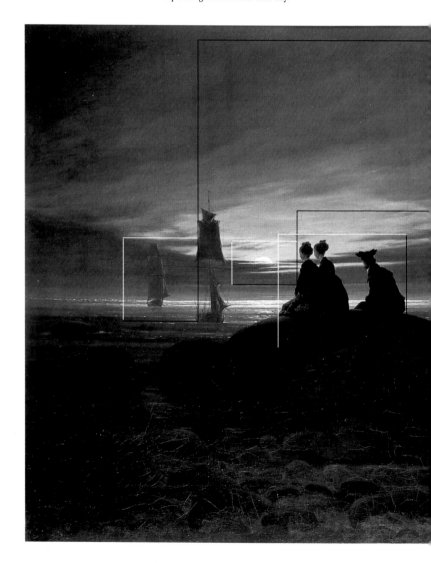

■ The ships, painted in deep shades of purple, sail away from the shore, bound for a distant promised land. Once again, Friedrich takes up the theme of the ship, used to symbolize man's voyage from life on earth to life in heaven.

■ The clouds part to reveal the light of the full moon (the painting's focal point), its silvery reflection illuminating the water of the Baltic Sea. The rising moon becomes the symbol of man's Christian belief in a life beyond.

■ The figures gazing out at the sea are dressed in traditional German costume. National dress was banned at the time because of its association with young liberals who wore it as a reaction against a strict conservative regime.

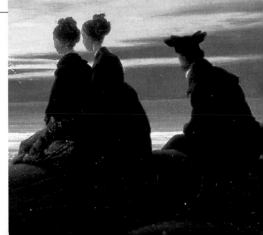

Neoclassical Europe

■ Anton Raphael Mengs, *Self-portrait*, 1771–77, Accademia linguistica di Belle arti, Genoa. Mengs' works illustrate the theoretical principles set out by Winckelmann.

■ Christoffer Wilhelm Eckersberg. *Bertel Thorvaldsen in the Uniform of the Academy of St Luke*, 1814, Kunstakademiet, Copenhagen.

■ Robert Adam, the Etruscan Room, Osterley Park, Osterley, Middlesex, 1761–77. Adam drew on ancient Etruscan vase painting for this decorative work.

"The only way for us to become great and, if possible, inimitable, is by imitating the ancients." Johann Joachim Winckelmann's opening words to his work of theory, *Thoughts on the Imitation of Greek Art* (1755), marked the beginning of a period known as Neoclassicism, which persisted until the mid-19th century in the sculptures of Canova and Thorvaldsen and the paintings of David and Ingres. According to Winckelmann, by imitating the work of the Greeks and Romans, artists would be able to attain the "noble simplicity and calm grandeur" found in the *Apollo Belvedere*, regarded as the most consummate masterpiece in ancient statuary. Imitation, however, should not mean a sterile copy of examples from antiquity but, rather, a revival of elements drawn from Greek, Roman, and other distant civilizations in order to create new, autonomous works of art. Greek and Roman antiquity was adopted as a point of reference for an artistic and cultural renaissance and for the attainment of the so-called "beautiful ideal", an aesthetic ideal that coincides with an ethical ideal. Art thus became the bearer of absolute moral values. The deathbed, the virtuous widow, and acts of political heroism are all recurrent themes in Neoclassical painting. The idea that a work of art should provide an example of moral integrity only started to wane in the 1860s, when Courbet declared that "painting is an essentially concrete art and can exist only in the portrayal of actual, real things."

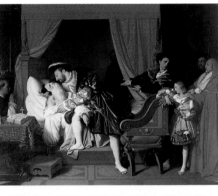

■ Below: Jean-Auguste-Dominique Ingres, *The Death of Leonardo da Vinci*, 1818, Musée du Petit Palais, Paris. The deathbed was a favorite subject with Neoclassical artists.

■ Below: Antonio Canova, *The Three Graces Dancing*, 1799, Casa Canoviana, Possagno. The dancing Graces echo some of the painted figures found at Pompei.

■ Above: Karl Friedrich Schinkel, 1822–23, Altes Museum, Berlin. Schinkel was inspired by the Ionic columns of Greek architecture for the museum's colonnaded facade.

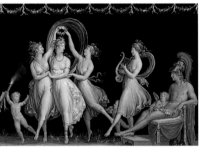

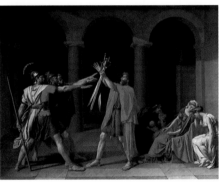

■ Below: John Soane, Bank of England, 1818, Sir John Soane's Museum, London. The columns with no bases or capitals are a free interpretation of the Greek Doric style.

■ Right: Jacques-Louis David, *The Oath of the Horatii*, 1785, Musée du Louvre, Paris. This painting shows the historic moment in which the three brothers vow to lay down their life for their country.

The Oath of the Horatii

David's painting can be regarded as the manifesto of Neoclassical art both in terms of its subject-matter and its artistic style. The artist exalts the moral and civil content of the scene, making the work a model of exemplary behavior. The rigid compositional structure, the resolute gestures of the brothers, and the severe colonnade in the background reinforce this view.

Friedrich, *Evening on the Baltic Sea*, 1831, Gemäldegalerie, Dresden

A renewed religious intensity

Disappointed by the political events that followed the Napoleonic period and the failed birth of a liberal German state, from the 1820s Friedrich stopped painting patriotic works and concentrated instead on creating religious art. He also stopped painting portraits of his wife Caroline which, charged with a symbolic and religious inner meaning, had represented a message of hope and confidence in the future. Works such as *Evening on the Baltic Sea* and *Ships in Harbor in the Evening*, on the other hand, are dark in color, and dominated by feelings of melancholy and resignation. Friedrich's progressive introspection was, however, not only due to the altered political situation but also had its roots in the fact that he felt increasingly isolated and misunderstood. The criticism directed at his paintings grew harsher, and his landscapes became monotonous, gloomy, and old-fashioned. Many collectors lost interest in him. The only possible solace he could find was in his faith, and the Christian element once again came to the fore in his work.

■ Below: Friedrich, *Cemetery in the Snow*, 1826, Museum der Bildenden Künste, Leipzig. The two spades, probably abandoned by grave-diggers, emphasize the feeling of loss and desolation conveyed by the painting.

■ Left: Friedrich, *Cemetery Entrance*, c.1825, Gemäldegalerie, Dresden. This unfinished painting shows us how Friedrich worked: a layer of brown color is applied first, with the other colors painted on top.

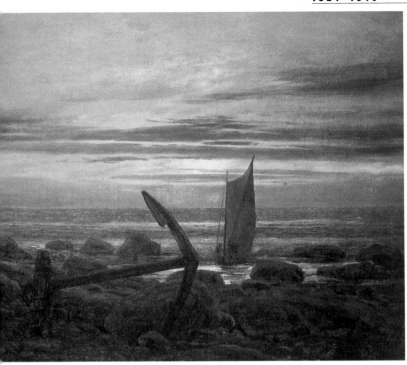

■ Friedrich, *Evening on the Baltic Sea*, 1826, Schäfer Collection, Obbach bei Schweinfurt. A lone sailing boat slowly pulls away from the coast at sunset. The abandoned anchor on the rocks in the foreground symbolizes hope and faith.

■ Friedrich, *Ships in Harbor in the Evening*, 1827–28, Gemäldegalerie, Dresden. The colored streaks across the sky, illuminated by the sun, are reflected in the sea, while the sails of the boats moored close to the shore remain in the shadows.

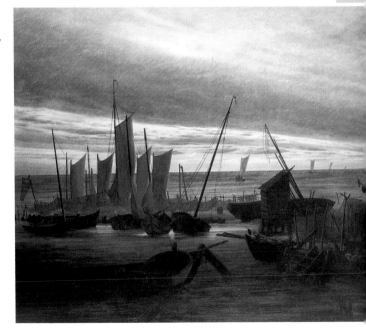

The Sea of Ice

This painting, also known as *Arctic Shipwreck* (1823–24, Kunsthalle, Hamburg), was inspired by the many expeditions to the North Pole undertaken by Sir William Parry's ship *Griper*.

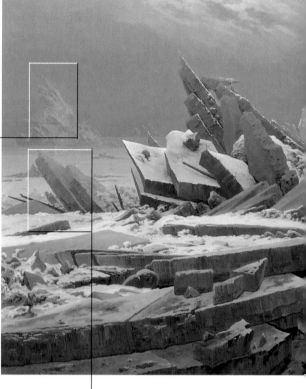

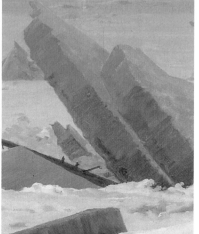

■ For his portrayal of the ice, Friedrich drew upon his studies in oil made during the winter of 1820–21, when the particularly cold temperature had caused the River Elbe to freeze over.

■ Among the sheets of ice the remains of the ship's masts can be made out. The wrecked ship is shown on the right of the painting. Exhibited at the Prague Academy in 1824, the work was not particularly popular and went unsold.

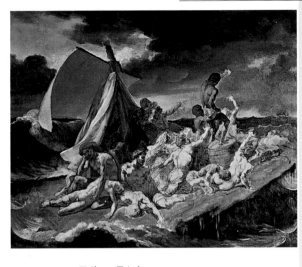

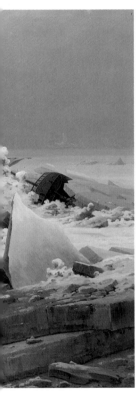

■ Above: Théodore Géricault, *The Raft of the Medusa*, 1818, Musée du Louvre, Paris. The preparatory drawing for this famous painting (1818–19) shows how Romantic artists favored the theme of the shipwreck as a symbol of the frailty of man before the elements.

■ Below: William Turner, *Slave Ship*, 1840, Museum of Fine Arts, Boston. Accidents at sea often feature in Turner's paintings: here, the ship's captain orders that the sick slaves be thrown overboard.

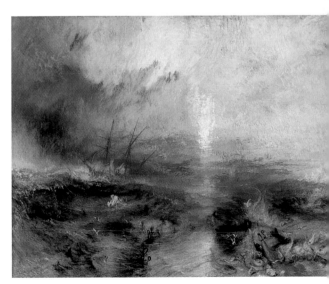

Constable's English landscapes

■ John Constable, *Landscape Study: Tree and Corner House*, 1822, Royal Academy of Arts, London. Constable considered his studies to be works of art in their own right, and saw no difference in status between a sketch and a painting.

While Friedrich was concerned with painting landscapes that mirrored his inner world and religious beliefs, in England the artist John Constable was producing landscapes that were very different in character. Although he displayed a keenly Romantic awareness in his interpretation of nature, Constable did not seek to alter reality through feeling. His clear and translucent life painting reflects his state of mind at the moment he stood before the landscape to be portrayed, but his work never becomes a symbol of his inner emotions. The oil painting *The Leaping Horse* is based on a detailed observation of the English countryside and on an accurate study of light and clouds, the latter a phenomenon of particular interest to Constable. His cloud studies all have the date as well as notes on the time of day and the weather conditions that prevailed. The artist's main objective was to capture the changeable aspects of nature, from the wind to the varying shades of light. With his sketches Constable aimed to catch the impression of a single moment, a quest that would be taken up in the second half of the 19th century by Claude Monet, Auguste Renoir, and the other Impressionist painters.

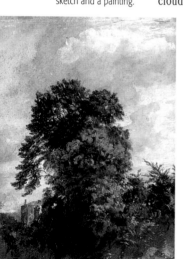

■ John Constable, *A Sand Bank at Hampstead*, 1821, Victoria and Albert Museum, London. This painting consists of delicate gradations in color.

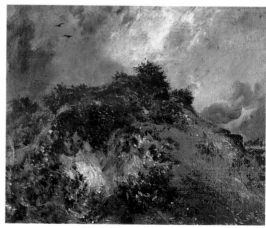

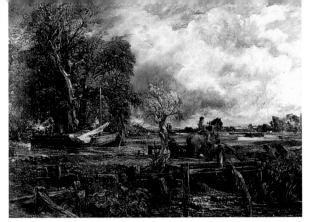

■ John Constable,
The Leaping Horse,
1824–25, Royal
Academy of Arts,
London. The people
in the boats on the left
of the painting look on
as the horse, about to
jump over the hurdle,
suddenly rears up.

■ John Constable, *A Grove, or Admiral's House, at Hampstead*, 1821, Victoria and Albert Museum, London. When Constable sat in front of nature in order to produce a sketch, his first concern was to try to forget that he had ever seen a painting in his life. He could thus produce works that reflected an immediate, spontaneous, and new vision of the landscape.

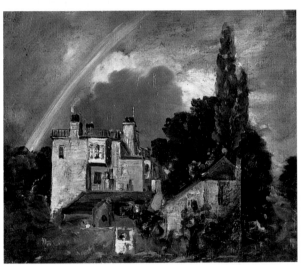

■ John Constable, *Landscape Study: Flatford Mill from a Lock on the Stour*, 1811, Royal Academy of Arts, London. The River Stour, in Suffolk, was one of Constable's favorite subjects, linked to the places where he spent his childhood. His father's mill was close to the Stour.

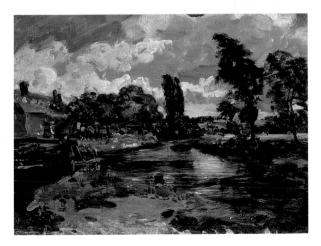

Professor Friedrich

Ln 1824, Johann Christian Klengel, leader of the Dresden landscape school of painting and professor at the city's Academy of Fine Arts, died at the age of 73. Many people expected Friedrich, a former pupil of Klengel's and a member of the Academy since 1816, to be invited to replace the illustrious teacher. The appointment was not forthcoming, however, the official reason given being that Friedrich had approached art by means of the "inner power of his genius" rather than through the study of the rules laid down by the Academy, a prerequisite for a suitable teacher. The chair remained vacant and Friedrich had to make do with an honorary professorship instead of a stable position, at a salary of 200 thaler per year. The real reason behind this slight is to be found elsewhere. It is more than likely that the members of the Academy, appointed by the king of Prussia, were not particularly in favor of Friedrich's political opinions, finding his liberal ideas inappropriate at a time when royal power was being restored. The episode, to which Friedrich reacted with apparent indifference (in a letter to his brother Adolf, he said that he never had any intention of setting out to obtain the post), nevertheless had a bearing on his increasing pessimism, which led him to seek solace in his faith and in memories of the past.

■ Left: Friedrich, *View of Putbus*, 1824, Pushkin Museum, Moscow. This drawing recalls his trip to Putbus, on the island of Rügen.

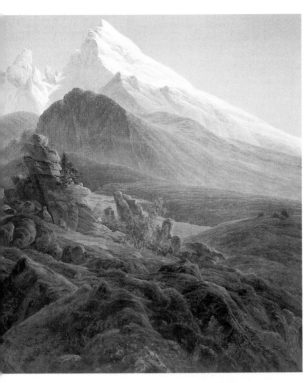

■ Friedrich, *The Watzmann*, 1824–25, Nationalgalerie, Berlin. Although Friedrich had never seen the Watzmann near Salzburg, he based this painting on an 1821 watercolor drawing by his favorite pupil August Heinrich.

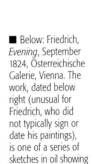

■ Below: Friedrich, *Evening*, September 1824, Österreichische Galerie, Vienna. The work, dated below right (unusual for Friedrich, who did not typically sign or date his paintings), is one of a series of sketches in oil showing the autumn sky.

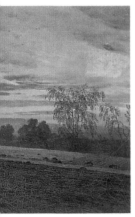

■ Above left: Friedrich, *Ploughed Field*, 1820–25, Kunsthalle, Hamburg. On the left of the picture, almost invisible, walks a small black figure holding a stick. It could be a farmer on his way home after a tiring day in the fields or a solitary wayfarer.

MASTERPIECES

Ruin at Eldena

This painting shows the ruined monastery of Eldena near Greifswald, a recurring motif in Friedrich's work since his earliest drawings of 1801. Painted in about 1825, *Ruin at Eldena* now hangs in Berlin's Nationalgalerie.

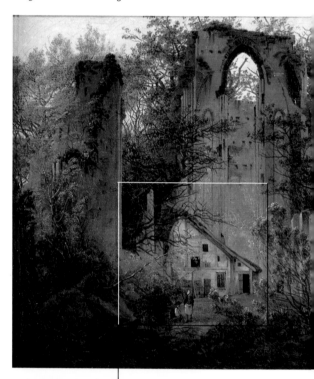

■ Deep in the woods and sheltered by the Gothic ruins, we can glimpse a house built in traditional German style. In front of it two men, one of them seated, turn to look towards the woods as if they have heard an unusual noise.

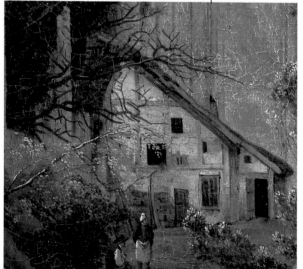

■ Right: John Constable, *Salisbury Cathedral from the Bishop's Grounds*, 1823, Victoria and Albert Museum, London. As in the Friedrich painting, Gothic architecture and nature are the main elements here. Unlike Friedrich, however, Constable does not convey a symbolic message in this painting.

■ Right: Friedrich, *The Ruins of the Monastery at Eldena*, 1824, Pushkin Museum, Moscow. The medieval monastery was Cistercian.

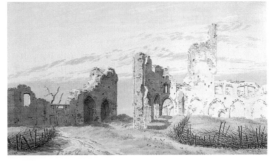

■ The ruined, weather-beaten Gothic arches become a symbol of the passing of time and the transitory nature of life, emphasized further by the broken-up fluting in the columns, the crumbling walls, and the dried-up branches.

■ Below right: Jean-Baptiste-Camille Corot, *Chartres Cathedral*, 1830, Musée du Louvre, Paris. Corot focuses on the Gothic cathedral and its spires, but he is not able to transcend reality and the work remains purely descriptive.

Romanticism elsewhere in Europe

The artistic trend known as Romanticism (from the English "romantic", a disparaging term that was used to describe chivalrous and pastoral romances) arose in the late 18th century among artists and writers who favored the expression of feelings, emotionalism, and the unconscious. Artists, poets, and even philosophers rediscovered the powers of the imagination, and revived an interest in the irrational and in history and popular traditions, setting them against the rationalism and cosmopolitanism that had so dominated the Enlightenment years. It was not a united movement, however: each country developed its own characteristics, leading to very different results. In Germany, a spiritual and religious art prevailed, whereas in England artists were drawn to oneiric and visionary images. In France, reality was transformed by the imagination of artists such as Delacroix, whereas in Italy, Francesco Hayez's work reflected a more historical form of Romanticism.

■ Below: Henry Fuseli, *The Nightmare*, 1781, Institute of Art, Detroit. The incubus, a demon that preys on sleeping women, rests on the body of the girl, while the head of a horse emerges from the dark background. According to legend, the incubus travels by night astride a horse.

■ Above: Francisco Goya, *Flight of Wizards*, 1797–98, Ministerio de la Gobernación, Madrid. The theme of dreams and the irrational recurs throughout Goya's work.

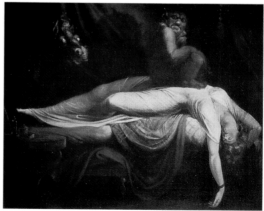

■ Francesco Hayez, *The Last Moments of Doge Marin Faliero*, 1867, Pinacoteca di Brera, Milan. Hayez drew mainly on historical events and contemporary novels.

■ Eugène Delacroix, *The Barque of Dante*, 1822, Musée du Louvre, Paris. This painting, inspired by Dante's *Divine Comedy*, shows Dante and Virgil in hell.

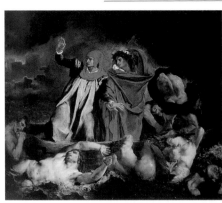

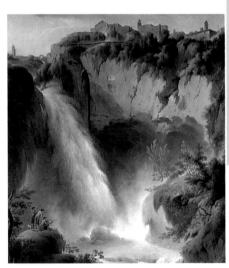

■ Below: Joseph Wright, *Vesuvius in Eruption*, 1774, Museum and Art Gallery, Derby. The English landscape artist Wright visited Naples in 1774.

■ Right: Michael Wutky, *The Tivoli Waterfall*, 1781, Galleria d'arte moderna, Florence. This painting gives a romantic and "sublime" view of the landscape.

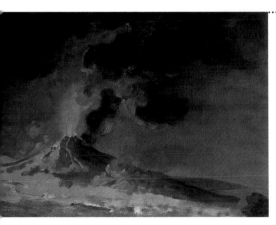

The sublime

The concept of the "sublime", which evolved in England around the middle of the 18th century, describes the feeling aroused by everything that gives rise to notions of grief and danger, such as the menacing power of nature, and is thus in opposition to the concept of the "beautiful ideal". The principal theorist of the sublime was Edmund Burke, who wrote *On the Sublime and Beautiful* in 1756 .

Friedrich's illness

Friedrich's health began to deteriorate progressively from 1824. His mental state, characterized by brusqueness and sudden fits of rage, was unstable and made his relationship with those around him very difficult. Never normally raising his voice, he would now turn on friends and relatives, treating them harshly. For no reason, he even accused his wife Caroline of having been unfaithful to him. After a period of enforced rest on the island of Rügen, during which he produced only a few drawings, Friedrich was able to recover and return to work. He now preferred drawing in sepia to working in oils. In 1828, he went to take the cure in the spa town of Teplitz (now Teplice), near Dresden. His isolation, bitterness, and loss of interest in life increased and he almost stopped painting altogether. These were difficult times for his family, who had to endure both the strain of the artist's delicate health and a financially precarious situation. By now, Friedrich's work was less in demand, the few purchasers coming from the artistic circles of Saxony and the Russian imperial court. On June 26, 1865, the situation took a turn for the worse: Friedrich suffered a stroke that left the right side of his body paralyzed.

■ Above: Friedrich, *The Ruins of Teplitz Castle*, 1828, Pushkin Museum, Moscow. This drawing dates from the time Friedrich spent in Teplitz, a well-known spa in Bohemia popular with tourists for its proximity to the mountains.

■ Left: Friedrich, *The Schlossberg Near Teplitz*, 1828, Kupferstichkabinett, Berlin. This pencil and watercolor drawing, dated March 3, 1828, shows the same subject as the painting above. Only the viewpoint has changed.

■ Below: Friedrich, *Ruin in the Woods Near Teplitz*, 1828, Nasjonalgalleriet, Oslo. During his stay in Teplitz, Friedrich made a number of trips into the surrounding countryside, finding many ideas for the works he produced in pencil or pen and ink, Here, he sketches the outline of a ruined castle in the woods.

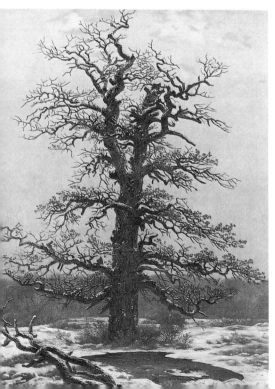

■ Left: Friedrich, *Oak Tree in the Snow*, 1827–28, Wallraf-Richartz-Museum, Cologne. The oak tree recurs as sole subject in many of Friedrich's works, including *Village Landscape in the Morning Light*, painted in 1822, which this painting closely resembles.

The Large Enclosure Near Dresden

Painted in about 1832 and now in Dresden's Gemäldegalerie, this work depicts a section of the game reserve on the south bank of the Elbe.

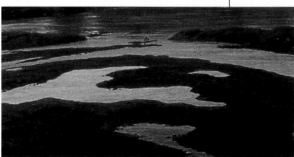

■ The water of the River Elbe seems to infiltrate into the ground, as if the artist wanted to create a symbolic image of life flowing towards its conclusion. The dramatic reflection of the light in the central section of the painting immediately claims our attention.

■ We can tell this is a late summer's evening from the position of the sun, which has already vanished behind the clouds, leaving a luminous trail in the sky. The dominant colors in the upper part of the canvas are the yellows of the sunlight and the delicate lilac of the clouds. The clouds form an arch that echoes the shape of the water in the lower part of the picture. This compositional device leads to the converging perspectival lines disappearing into the distance.

■ Set against the row of trees in the background is the pale grey sail of a vessel sailing slowly along the river. It will not get far and will most likely end up on the sand: once again, the boat is used as a symbol of life coming to a close.

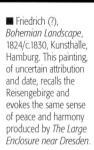

■ Friedrich (?), *Bohemian Landscape*, 1824/c.1830, Kunsthalle, Hamburg. This painting, of uncertain attribution and date, recalls the Reisengebirge and evokes the same sense of peace and harmony produced by *The Large Enclosure near Dresden*.

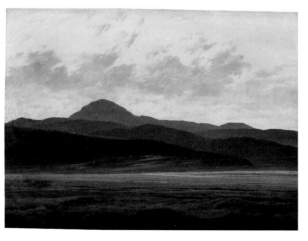

The missed trip to Italy

At a time when many northern European artists were strongly attracted to Italy, it seems surprising that Friedrich never once paid a visit to the country. In all fairness, he did toy with the idea, albeit briefly, in 1816, when his friend Lund suggested that he joined him in Rome. "Indeed I would like to come to Rome and live there. But I would then dread returning north again: it would be like being buried alive…" wrote Friedrich in reply. "I could happily remain in one place without complaining about it, if my fate dictates thus, but I could never retrace my steps, it would be like going against my very nature." The real reason behind his refusal was quite different, however: Friedrich did not care for the paintings by the German artists living in Rome and was particularly ill-disposed to the heroic vision of landscape espoused by Koch and Reinhart. He was too engrossed in the northern concept of landscape to yield to the charms of Italy. He also disagreed with those who felt that everything should "be Italian" and did not believe it was necessary to go to Rome to be a good landscape painter. No one will ever know how his work might have been influenced had he made the trip.

■ Antonio Joli, *View of Paestum*, Duke of Buccleuch K.T. Collection, Bowhill, Selkirk. Paestum was one of the sights visited on the Grand Tour.

■ Friedrich (?), *The Temple of Juno at Agrigento*, c.1830, Museum für Kunst und Kulturgeschichte, Dortmund. This painting, of uncertain attribution (it may be by Carus), is the only oil painting that Friedrich made of ancient ruins.

■ Porcelain bowl with lid, Museo Duca di Martina, Naples. Pompeiian dancers, as painted on this dish, were widely reproduced in the 18th century.

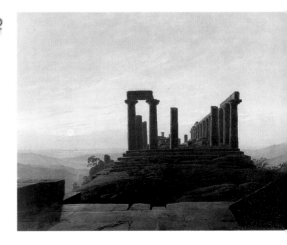

■ Friedrich, *Landscape With Temple Ruins*, 1802, Herzog-August Bibliothek, Wolfenbüttel. Friedrich felt that it was enough to study accurate engravings in order to draw ancient ruins, and did not consider it necessary to visit Italy and its sights.

■ Friedrich, *Ancient Temple*, 1794, Staatsgalerie, Stuttgart. This pencil and watercolor drawing dates from the artist's student days at the Copenhagen Academy. The Gothic ruins are here replaced by classical architecture.

■ Joseph-Marie Vien, *The Cupid Seller*, 1763, Musée du Château, Fontainebleau. Vien based this work on an engraving from the *Antiquities of Herculanum* (1757–59)

■ Jakob Philipp Hackert, *Amphitheatre at Pompeii*, 1793, Stiftung Weimarer Klassik, Weimar. Ancient sites were popular among the fashionable, who came to stroll among the ruins.

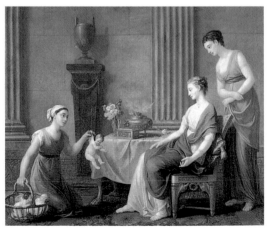

The discovery of Pompeii

In 1748, ten years after the discovery of Herculanum, the ruins of Pompeii unexpectedly emerged from the past and seduced scholars and artists alike. They came from all over Europe to visit the scenes of the "unforgettable calamity" of AD 79 described by Pliny the Younger. The sights of Pompeii, including the temple of Isis and the villa of Diomedes, recur in the paintings and diaries of travellers fascinated by the vestiges of a remote civilization.

The Industrial Revolution

As Friedrich continued to portray the image of a nature unsullied by man, profound changes were taking place in the world. Progress in the field of science and technology meant that agricultural output was able to increase dramatically, satisfying the requirements of a growing population and providing investment for new research and technological discoveries. The steam engine, invented by James Watt in 1769, was enormously successful throughout Europe, so much so that between 1830 and 1846 Prussia increased its quota from about 200 to more than 1,000. Transport, which had remained essentially unchanged for more than 2,000 years, also underwent a change: carts, boats, and horses were replaced by locomotives and steamships. Industrialization also brought about radical changes in society. The ownership of factories and machinery was now more important than the possession of chattels, and the feudal society and the pre-eminence of the aristocracy were in decline. The growing industrialization, however, was not without its attendant problems, including a rise in poverty among the lowest classes and the enforced employment of women and children. The problems of modern society had begun.

■ Right: Joseph Wright of Derby, *The Iron Forge*, 1770–72, Broadlands Trust, Hampshire. This painting, purchased by Catherine the Great in 1774, shows how metal was worked. Wright of Derby painted many industrial scenes and became one of the major chroniclers of this period.

■ Below: Anonymous, *A Visit to the Steel Foundry*, 1859. Working conditions in the factories were extremely harsh, with employees often working up to 16 hours or more a day.

■ James Nasmyth, *A Steam Hammer at Work*, 1871, Science Museum Library, London.

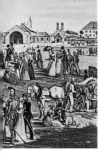

■ Left: this lithograph is of the opening of the Munich–Aachen railway on September 1, 1839. The first trains were viewed with suspicion, and doctors feared for the passengers' mental health.

■ Above: children were often forced to carry out jobs that adults were unable to do because of their size, such as pushing carts down the mines or sweeping chimneys.

■ Below: William Turner, *Rain, Steam, Speed*, 1844, National Gallery, London. Thanks to the diagonal structure of the painting and the gradual disintegration of the forms, Turner succeeds in powerfully conveying the speed of the train.

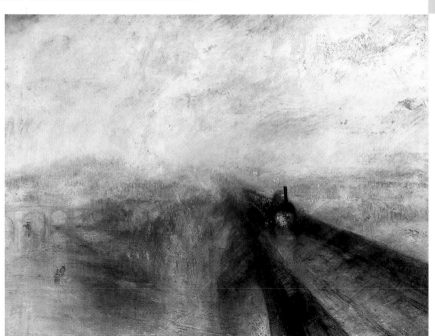

The Evening Star

This painting shows a mother and her two children returning home after a stroll through the fields on an autumn afternoon. Painted between 1830 and 1835, the work is currently in the Freies Deutsches Hochstift in Frankfurt.

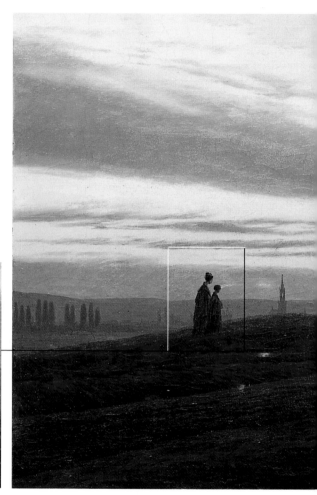

■ The two female figures walking side by side and looking towards the city are possibly Friedrich's wife Caroline and his younger daughter Adelheid, who would have been about ten years old at the time.

■ Rows of poplars surround the city and form two side-props for the painting. They also close the horizontal line created by the figures, and the steeples. Here, the poplars are symbols of death.

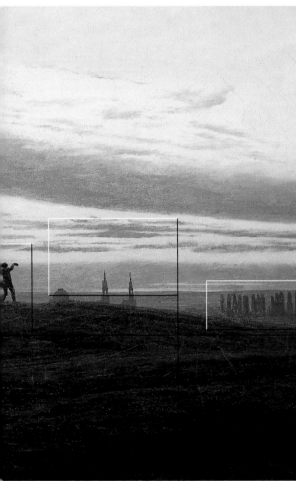

■ The boy, possibly Friedrich's son, pauses on the hilltop and greets the city, expressing his joy at returning home after a long walk. The work becomes a symbol for life drawing to a close.

■ In the distance lies Dresden, recognizable by the dome of the Frauenkirche, the Residenzschloss, and the bell-tower of the Hofkirche. Moved to the right is the bell-tower of the Kreuzkirche. Behind the city, the setting sun lights up the sky.

BACKGROUND

Heinrich Heine and the "Vormärz" literature

The so-called "Vormärz" period describes the years between the Congress of Vienna in 1815 and the March revolution, which broke out in Vienna and spread to Berlin and other German cities between 1848 and 1849. The restoration of the old monarchies and the persistent fragmentation of the German territories provoked a strong opposition to the conservative system of the day. Driven by their belief in political, economic, and social reform, and aware of the widespread revival of a strong sense of national identity, Metternich's opponents held liberal political views and, in particular, felt it was necessary to form a German national state based on a democratic and parliamentary system. In literature, too, many sympathized with the fight against the old feudal system, the poverty endured by the lower social classes, and the repression of freedom of thought. Heinrich Heine and the circle of writers known as *Junges Deutschland* (Young Germany), together with the playwright Georg Büchner, were among the intellectuals most actively involved in this struggle. Opposing Romanticism, they put forward a literature that had its roots in reality, topical issues, and progress, a literature that would become the mouthpiece for the political and social life of a whole nation. Büchner even incited the farmers of Hesse to insurrect. His premature death, however, prevented him from witnessing the outbreak of the 1848 uprisings.

■ Poster advertizing the premiere of *Der Freischütz* by Carl Maria von Weber, June 1821. The first opera to be written in German, it was an expression of the German nationalist feeling that was revived in the early 19th century.

■ August Hoffmann, *Georg Büchner*, 1833–34, Heinrich-Heine-Institut, Düsseldorf. This is a photograph of the original portrait, unfortunately destroyed in World War II.

■ Ernst Benedikt Kietz, *Heinrich Heine and his Wife Mathilde* (detail), 1851. Heine spent the last years of his life in Paris, forced into exile by his openly voiced political views against a repressive and conservative state.

■ Moritz Oppenheim, *Heinrich Heine*, 1831, Heinrich-Heine-Institut, Düsseldorf. Heine's major political works include the satirical poem *Deutschland. Ein Wintermärchen*.

■ Right: the civil unrest that erupted in July 1830 in France gave a fundamental impetus to the German nationalist movement. Even the *Junges Deutschland* literary group, which besides Heine also included Gutzkow, Börne, and Laube, was set up after the French uprisings.

■ Left: Document affirming the ban on the *Junges Deutschland* movement, published in the "Fürstlich Schwarzblatt" on January 3, 1836.

The last years

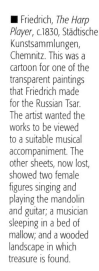

■ Friedrich, *The Harp Player*, c.1830, Städtische Kunstsammlungen, Chemnitz. This was a cartoon for one of the transparent paintings that Friedrich made for the Russian Tsar. The artist wanted the works to be viewed to a suitable musical accompaniment. The other sheets, now lost, showed two female figures singing and playing the mandolin and guitar; a musician sleeping in a bed of mallow; and a wooded landscape in which treasure is found.

Like Runge and many other Romantic artists, Friedrich always wanted to achieve a *Gesamtkunstwerk*, a complete and comprehensive work of art, and so experimented with new techniques throughout the last years of his life. He painted in watercolor and tempera on transparent sheets of paper, placing a light source behind them. He would then, in total darkness, light up his works one by one, and they could be admired to the sound of suitable music that would match the content of the painting being viewed. Friedrich himself gave precise indications as to how this experience should be organized, in a letter to the poet Wassily Zhukovsky, who had purchased four *Transparentmalereien* (Transparent Paintings), now lost, for the Russian Tsar's collection. Zhukovsky paid his last visit to Friedrich in 1840, by which time the artist was no longer able to paint: "A sad, ruined man. He cries like a child," noted the poet. After the stroke he had suffered in 1835, Friedrich took the cure at the Teplitz spa and recovered sufficiently to resume drawing and painting. A second stroke in 1837, however, resulted in almost complete paralysis and a decline in his mental state. By 1839 he was no longer able to work and he died on May 7, 1840.

■ Below: Friedrich, *Mountainous River Landscape*, 1830–35, Neue Galerie, Kassel. Using the same sheet of transparent paper Friedrich painted the sunset on one side and the same view by day (below right) on the other side. The landscape changes, arousing different emotions in the viewer.

■ Friedrich, *The Dreamer*, 1835, State Hermitage Museum, St Petersburg. Seated on a Gothic ruin in a wood, a young man pauses to contemplate the setting sun.

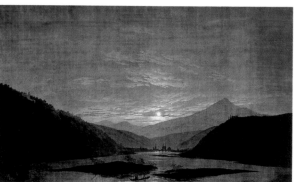

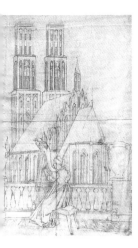

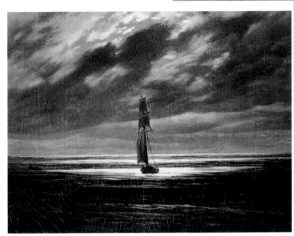

■ Above: Friedrich, *Sea Piece by Moonlight*, 1830, Museum der Bildenden Künste, Leipzig. The lonely ship sailing into the distance expresses all the melancholy of Friedrich's final period.

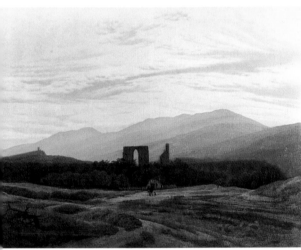

■ Friedrich, *Ruins in the Riesengebirge*, 1835, Museum der Stadt, Greifswald. The Riesengebirge mountains are recurrent features in Friedrich's work.

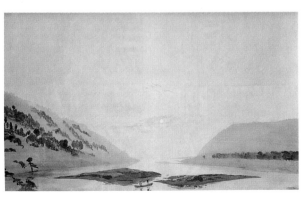

■ Friedrich, *River Landscape in the Mountains*, 1830–35, Neue Galerie, Kassel. The glaring sunlight prevents us from knowing what lies at the foot of the mountains in the distance. The distance is discernible, however, in Friedrich's nocturnal view of the same landscape, the *Mountainous River Landscape* (opposite).

The Stages of Life

This is an allegorical work showing the cycle of human life. Friedrich painted it in 1835, when his health had already begun to deteriorate. It is now housed in the Museum der Bildenden Künste in Leipzig.

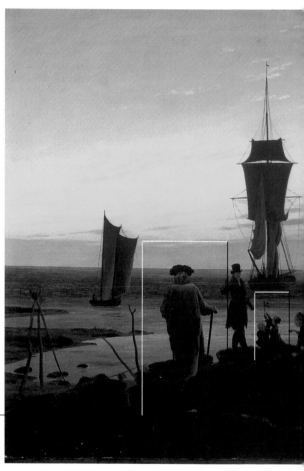

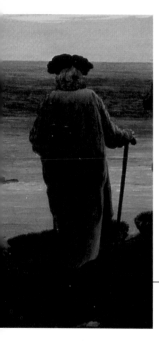

■ It is likely that the old man seen from behind, who slowly approaches the other figures, is Friedrich himself. He wears a long coat and a fur hat, as though he feels the cold on this fine summer's day. He seems not to notice the man calling out to him with a gesture of the hand, and his gaze is directed elsewhere.

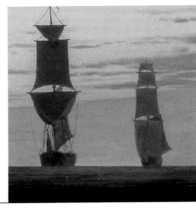

■ Below: the children on the shore are each trying to snatch a small Swedish flag, with its traditional blue and yellow design. Friedrich had always been fond of Sweden. When he was born, Greifswald had been under Swedish rule.

■ The ships sailing away on the sea take on the lilac-grey color of the clouds and appear to be more of a mirage than a real vision. As symbols of man's transition to life in heaven, they seem to announce the artist's own death, which would take place just a few years later.

■ Below: hidden in the shadows, the shape of the upturned boat on the shore recalls that of a coffin. It is angled towards the old man with the stick, possibly as a message of impending death.

BACKGROUND

In Friedrich's footsteps

■ Carl Blechen, *Sun on the Sea*, 1829, Nationalgalerie, Berlin. During his stay in Italy, the artist painted more luminous and less anguished landscapes than usual.

"It seems to me that Friedrich's method of conception leads in a false direction…Friedrich chains us to an abstract idea, making use of the forms of nature in a purely allegorical manner, as signs and hieroglyphs – they are made to mean that and that." These words, written in Dresden in 1824 by Adrian Ludwig Richter, clearly express the unease felt by many of the new generation of artists when viewing Friedrich's paintings. His art had no followers as such but spawned imitators who, using his spiritual landscapes for inspiration, achieved totally different results. Richter's *Crossing the Schreckenstein*, albeit representing an allegorical image of the "ship of life", harbors no hidden messages of any religious profundity. His description of nature is more objective and faithful than Friedrich's. August Heinrich's sensitive realism, Oehme's snow-covered cloisters, Karl Friedrich Lessing's imaginary scenery, and Blechen's dreamlike atmosphere all draw on Friedrich's iconography, but have nothing in common with the spiritual experience aroused by the master's paintings. Friedrich remained misunderstood and forgotten for a long time. It was left to the artists of the 20th century to rediscover and re-assess his work and to establish its importance.

■ Below: Karl Friedrich Lessing, *Convent Cemetery in the Snow*, 1830, Wallraf-Richartz-Museum, Cologne. This painting features a medieval monastery in a winter landscape. Inside, we can glimpse a procession of monks.

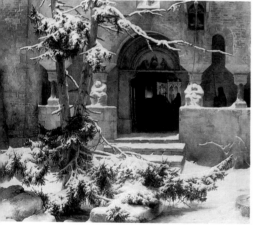

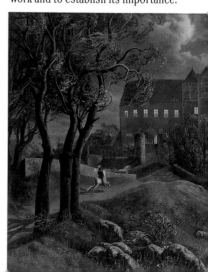

■ Right: Ernst Ferdinand Oehme, *Castle on a Mountain Top at Night*, 1827, Nationalgalerie, Berlin.

Oehme was initially influenced by Friedrich, moving later towards a more heroic conception of landscape.

■ Below: Carl Blechen, *The White Cliffs at Rügen*, 1828, Niederlausitzer Landesmuseum, Schloss Branitz, Cottbus. The scenery in this painting is both naturalistic and fantastical and far removed from Friedrich's spiritual landscapes.

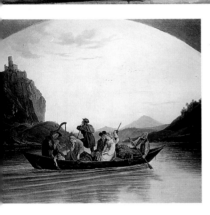

■ Above: Adrian Ludwig Richter, *Crossing the Schreckenstein* (detail), 1837, Gemäldegalerie, Dresden.

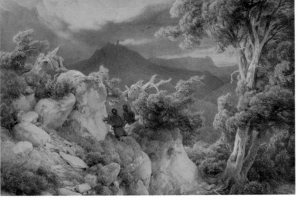

■ Above: Karl Friedrich Lessing, *Stormy Mountain Landscape with Two Pilgrims*, 1841, Kunstmuseum, Düsseldorf. Lessing, who trained under Schadow, favored medieval themes, such as the religious wars of the 15th and 16th centuries.

Friedrich and the artists of the 20th century

When nine Friedrich paintings were destroyed in a fire in Munich in 1931, Max Ernst declared that art had suffered a grave loss. He had discovered works painted by the master, who was at this time totally forgotten, some ten years previously in a Cologne museum and had immediately sensed the affinities he shared with the Romantic artist's vision. In his Dada and Surrealist works we can see the trees and woods and the ambiguous, mysterious figures of Friedrich, while the abstract paintings of Mark Rothko, dating from the 1950s, suggest the same vision of infinite space expressed in *Monk on the Seashore*. Pollock's *Enchanted Forest* could easily be the same woods that menacingly await the Napoleonic soldier in *The "Chasseur" in the Woods*, just as the figures with their back towards us in Magritte's paintings recall the unknown faces of Friedrich's figures. In a sense, the spiritual quality of Friedrich's art anticipates the Dada, Surrealist, and abstract trends of the 20th century, whose exponents have more or less consciously adhered to his artistic legacy.

■ Mark Rothko, *Light, Earth, and Blue*, 1954, Private Collection. The two areas of color, divided by a thin pale blue line, are juxtaposed like the sea and the sky in Friedrich's *Monk on the Seashore*. Color and space dilate beyond the edges created by the monochrome background.

■ Max Ernst, *Two Ambiguous Figures*, 1919, Private Collection, Meudon. Unlike Friedrich's figures, the disturbing ones painted by Ernst do not have their back to us but face the viewer head on.

■ Below: Nicolas de Staël, *The Moon*, 1953, Françoise de Staël Collection. Pale and mysterious, De Staël's moon is similar to Friedrich's moonscapes, while the red strip in the lower section recalls *Monk on the Seashore*.

■ Left: Jackson Pollock, *Enchanted Forest*, 1974, Peggy Guggenheim Collection, Venice. The title of the work brings to mind many of Friedrich's paintings, whereas the energy and dynamism recall the visionary landscapes of another Romantic artist, Turner. Friedrich's work came to be reassessed in 1972, with a retrospective exhibition mounted by the Tate Gallery in London.

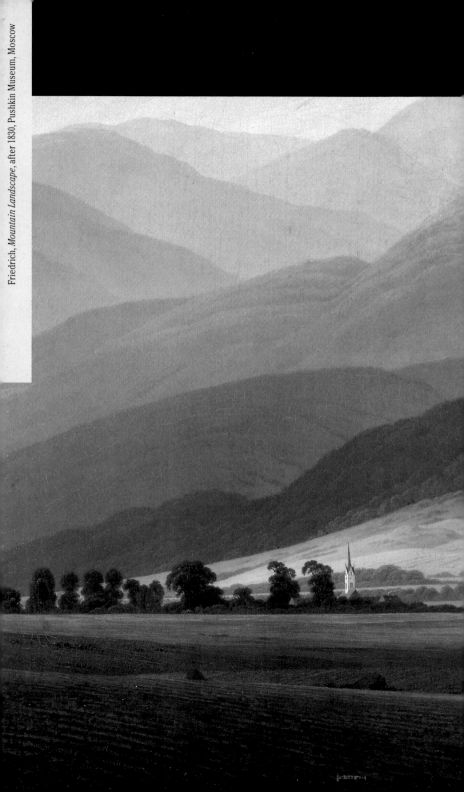

Index

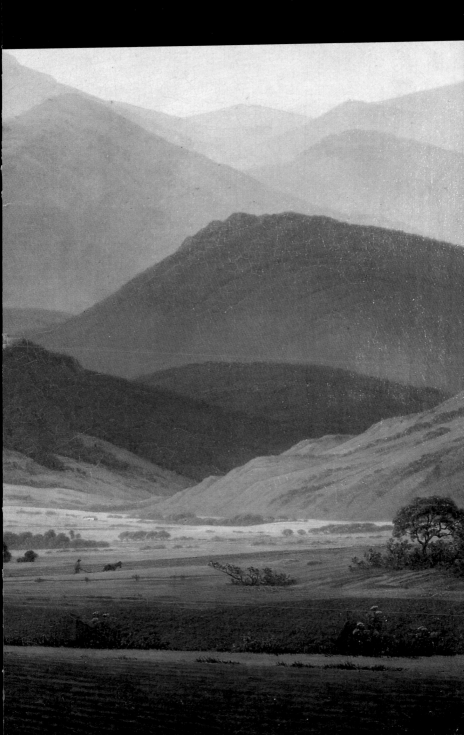

Note

The places listed in this section refer to the current location of Friedrich's works. Where more than one work is housed in the same place, they are listed in chronological order.

■ Hamburg, Kunsthalle.

■ Friedrich, *Sunset,*
1830, State Hermitage
Museum, St Petersburg.

■ Friedrich, *Entrance
Through the Rocks in
the Utterwalder Grund,*
c.1801, Museum
Folkwang, Essen.

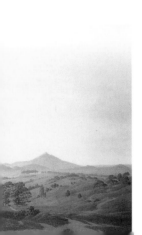

■ Friedrich, *Bohemian
Landscape,* 1810,
Gemäldegalerie, Dresden.

Note

All the names mentioned here are artists, intellectuals, politicians, and businessmen who had some connection with Friedrich, as well as painters, sculptors, and architects who were contemporaries or active in the same places as Friedrich.

Abildgaard, Nicolai Abraham (Copenhagen 1743 – Frederiksdal 1809), Danish painter. An important Neoclassical painter, his work reveals a certain pre-Romantic sensibility. As director of the Copenhagen Academy, he greatly influenced the young Friedrich, pp. 12, 13, 14, 75.

Bechly Sophie Dorothea (1747–1781), Friedrich's mother. Originally from Neubrandenburg,

■ John Constable, *White Horse*, c.1819, Widener Collection, National Gallery, Washington.

she died in 1781, when the artist was only seven years old, p. 8.

Blake, William (London 1757–1827), English painter, engraver, and poet. An exceptional man, he produced mainly allegorical figures inspired by his favorite literary sources, including the Bible and Shakespeare. As a writer and painter, his vision of the world became charged with visionary and prophetic tones, making him one of the first true Romantics, pp. 42, 43, 74, 75.

Blechen, Carl (Kottbus 1798 – Berlin 1840), German painter and stage designer. Initially influenced by the Romantic works of Friedrich and Dahl, his paintings later veered more towards realism, pp. 83, 130, 131.

Bommer, Christiane Caroline, Friedrich's wife, whom he married in 1818, pp. 66, 67, 70, 81, 92, 122.

Brückner, Ernst Theodor (1746–1805), German poet. Also active as a translator and the pastor at Neubrandenburg. He was a relative by marriage to the Friedrich family, p. 12.

Carstens Jacob Asmus (Sankt Jürgen 1754 – Rome 1798), Danish-German painter. He

■ William Blake, *The Good and Evil Angels*, c.1795, Tate Gallery, London.

studied at the Copenhagen Academy and developed a figurative language that focused on antiquity, and a monumental art that portrayed mythological subjects, pp. 24, 42, 43, 75.

Constable, John (East Bergholt 1776 – London 1837), English painter. One of the foremost landscape painters of his time. He painted many of the same subjects over again, observing natural phenomena as they happened, portraying them from life in numerous preparatory sketches and finished paintings. His works look ahead to the high point of Impressionism, pp. 53, 106, 107, 110.

Cozens, John Robert (London 1752–1797), English painter. One of the more "southern" of the English landscape painters, who painted scenes of the Italian Alps and the countryside in evocative watercolors. He rejected a topographical rendering of landscape in favor of a vibrant atmospheric interpretation and subtle evocation, which would influence Turner, pp. 52, 53.

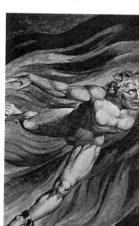

■ Jacques-Louis David, *Brutus Condemning his Son*, 1789, Musée du Louvre, Paris.

Dahl, Johan Christian Clausen (Bergen 1788 – Dresden 1857), Norwegian painter who studied at the Copenhagen Academy. On moving to Dresden, Dahl became a lifelong friend of Friedrich. His paintings reveal a Romantic sensibility, expressed through a dramatic and heroic vision of nature, pp. 48, 49, 76, 77, 93.

David, Jacques-Louis (Paris 1748–Brussels 1825), French painter. One of the foremost Neoclassical painters, David refined his style while on a visit to Italy. His civil and political fervor found their full expression in eloquent works full of emotional impact. He lived through the troubled history of his time first as an ardent supporter of the French Revolution and subsequently as official painter to Napoleon, pp. 98, 99.

Fichte, Johann Gottlieb (Rammenau 1762 – Berlin 1814), German philosopher. A major cultural figure of his age, he laid the foundation for the scientific doctrine that placed the self at the center of the universe, a philosophy that would be of fundamental importance for the writers and artists of the Romantic period, p. 28.

Fouqué, Friedrich Heinrich Karl de la Motte (Brandenburg 1777 – Nennhausen 1843), German writer. Fouqué reworked German literature from its origins, becoming a fashionable writer who was in contact with Romantic artists and writers, pp. 29, 92.

Frederick of Prussia (Berlin 1795 – 1861), son of Frederick William III, who became King Frederick William IV, p. 50.

Frederick William III (Potsdam 1770 – Berlin 1840), king of Prussia. He was responsible for instituting many reforms, pp. 54, 60.

Friedrich, Adolph Gottlieb, Friedrich's father. In order to support his large family, he worked as a soap- and candle-maker. He was responsible for providing Friedrich with his early religious education, pp. 8, 9.

Friedrich, Adolf (1770–1838), the artist's brother, p. 108.

Friedrich, Agnes Adelheid, Friedrich's second daughter, born in 1823, pp. 66, 122.

Friedrich, Christian (1779–1843), one of Friedrich's brothers, he was a carpenter and engraver, p. 71.

Friedrich, Elisabeth, Friedrich's sister, who died when the artist was still a young boy, p. 72.

Friedrich, Emma, Friedrich's eldest child, born in 1819, pp. 66, 92.

Friedrich, Gustav the artist's son, born in 1824, p. 66.

■ Friedrich, *Riesengebirge (Dawn)*, 1830–35, Nationalgalerie, Berlin.

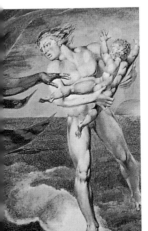

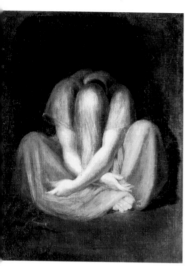

■ Henry Fuseli, *Silence,*
1799, Kunsthaus, Zurich.

Heinrich Füssli) but English by
adoption. While on a journey to
Rome in 1770, he was deeply
impressed by the works of
antiquity and by Michelangelo's
Sistine Chapel. The oneiric and
visionary quality of his work would
have a marked influence on
William Blake, pp. 29, 74, 75, 112.

**Géricault, Jean-Louis-
Théodore** (Rouen 1791 – Paris
1824), French painter. A pupil
of David, he became the major
exponent, together with
Delacroix, of French Romanticism.
His works are characterized by
vibrant energy and drama, and
reveal a meticulous portrayal
of reality, seen also in its
cruellest aspects, p. 105.

Goethe, Johann Wolfgang
(Frankfurt-am-Main 1749 –
Weimar 1832), German writer.
A man of great culture, Goethe
witnessed the many changes
that took place during his
lifetime and also produced
scientific works. His complex
personality, his tendency towards
a bourgeois humanism, but also
the value he placed on freedom
and his passion for science are
reflected in his work, which
culminated in his great
masterpiece, *Faust,*
pp. 10, 11, 18, 48, 69, 94.

Friedrich, Heinrich
(1777–1808), one of Friedrich's
brothers, a candlemaker like
his father, p. 82.

**Friedrich, Johann
Christopher**, Friedrich's
brother, who drowned in 1787
at the age of 12, p. 72.

Friedrich, Maria, Friedrich's
sister, p. 72.

Fuseli, Henry (Zurich 1741 –
London 1825), painter of Swiss
origin (his real name was

Heinrich, August, painter
and one of Friedrich's favorite
pupils. He portrayed Friedrich
in a few of his paintings,
pp. 80, 109, 130.

**Hoffmann, Ernst Theodor
Amadeus** (Königsberg 1776 –
Berlin 1822), German writer
and musician. One of the most
original of all European writers, he
gave Romanticism his own personal
interpretation. In his magical and
grotesque creations, the universe
appears to be turned upside down
in order to reveal the deepest
truths about the individual, p. 28.

Juel, Jens (1745–1802),
Danish painter. A landscape
artist, he taught at the
Copenhagen Academy, p. 12.

Kersting, Georg Friedrich
(Güstrow 1785 – Meissen 1847),
German painter who became
a lifelong friend of Friedrich.
Kersting expressed his Romantic
inclination mainly through
subjects taken from everyday

■ Theodore Géricault,
Envious Madwoman,
1822–23, Musées des
Beaux-Arts, Lyons.

■ Joseph Anton Koch, *Lattaslital near Meiringen*, 1817, Tiroler Landesmuseum Ferdinandeum, Innsbruck.

petit-bourgeois life, with features that paved the way for the Biedermeier style, pp. 46, 66, 67.

Kleist, Heinrich von (Frankfurt-am-Oder 1777 – Wannsee 1811), German writer. A powerfully dramatic artist, his works are a blend of irrational Romantic themes and stylistic sobriety, through his interest in the Enlightenment and the philosophy of Kant, pp. 30, 56.

Klengel, Johann Christian (1751–1824), German painter. An exponent of the Dresden landscape school and professor at the Academy of Fine Arts, he taught Friedrich, pp. 16, 108.

Koch, Joseph Anton (Obergibeln 1768 – Rome 1839), Austrian painter who spent most of his life in Rome. He developed a style of landscape painting that was classical in inspiration and came into contact with the Nazarenes, with whom he worked on the frescoes in the Casino Massimo, pp. 24, 25, 48, 94, 118.

Kosegarten, Gotthard Ludwig (1758–1818), German theologian and writer. Author of Protestant texts that were strongly Pietist in content, he expressed the new religious mood of the age through his poems and idylls, pp. 8, 14, 15, 22.

Kügelgen, Franz Gerhard von (Bacharach 1772 – Dresden 1820), German artist. Court painter in St Petersburg, he befriended Friedrich on his return to Dresden in 1805. His portraits and historical paintings, Neoclassical in style, reveal elements of Romanticism, pp. 11, 93.

Kühn, Christian Gottlieb, German sculptor. A friend and colleague of Friedrich, for whom he made the frame for *The Cross in the Mountains*, p. 46.

Lorentzen Christian August (1749–1828), Danish painter. A landscape artist, he taught at the Copenhagen Academy, p. 12.

Lund Johan Gebhard (1777–1867), Danish painter. A landscape artist and a great friend of Friedrich, whom he met at the Copenhagen Academy, pp. 12, 118.

Mutter Heiden, family friend and nurse who helped to bring up the Friedrich children after the death of their mother, p. 9.

Nicholas I (1796–1855), Tsar of Russia. An admirer and patron of Friedrich. He supported the artist's family for many years, even after Friedrich's death, pp. 67, 92.

Novalis, Friedrich Leopold von Hardenberg known as (1772–1801), German poet. One of the most important early Romantic writers, his works express a deeply spiritual vision, based on the desire for union between man and God, p. 29.

Oehme, Ernst Ferdinand (Dresden 1797–1855), German painter and follower of Friedrich. His landscapes,

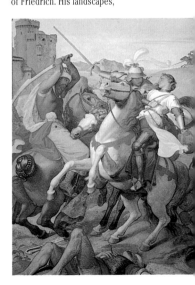

■ Friedrich Overbeck, *Odoardo and Gildippe*, 1823, Casino Massimo, Rome.

although similar to Friedrich's work in their spirituality, are more descriptive, pp. 45, 130.

Ossian (third century AD), legendary Scottish prince, to whom Gaelic medieval tradition attributed a series of epic poems. His odes, written by James Macpherson, who claimed to have translated them, were widely popular during the Romantic period for their dark and melancholy quality, pp. 14, 74, 75.

Overbeck, Friedrich (Lübeck 1789 – Rome 1869), German painter. Together with a group of friends, including Franz Pforr, he founded the Nazarene group in Rome. The Nazarenes were inspired by both Germanic and Italian medieval religious art, pp. 92, 93, 94.

Quistorp, Johann Gottfried, professor of technical drawing at the University of Greifswald. He taught Friedrich from 1790, the artist producing his first

■ Johann Christian Reinhart, *View of the Old Waterfall at Tivoli*, 1813, Private Collection.

studies under his expert eye, pp. 8, 12, 14.

Reinhart, Johann Christian (Hof 1761 – Rome 1847), German painter. Having attended the Dresden Academy, he moved to Rome and painted landscapes that veered increasingly towards an ideal description of the world around him, pp. 24, 25, 48, 118.

Richter, Adrian Ludwig (1803–1885), German painter. Mainly active in Dresden, he broke away from the Romantic trend in favor of a more subdued vision of reality, in which ordinary men and women played a central role, pp. 89, 130, 131.

Runge, Philipp Otto (Wolgast 1777 – Hamburg 1810), German painter. The founder, together with Friedrich, of German Romantic painting. The allegorical figures in his few works express a pantheistic view of nature and a new harmony between man and the world around him, while his portraits reveal a sharp psychological insight, pp. 38, 39, 75, 126.

Schelling, Friedrich Wilhelm Joseph (Leonberg 1775 – Bad Ragaz 1854), German philosopher.

One of the key figures of the Romantic period through his research into the philosophy of nature, pp. 28, 30.

Schiller, Friedrich (Marbach am Neckar 1759 – Weimar 1805), German writer. His early works were rooted in the *Sturm und Drang* movement and, together with Goethe, he became the main exponent of German classicism, putting forward an ideal of beauty that coincided with truth, pp. 10, 11.

Schinkel, Karl Friedrich (Neuruppin 1781 – Berlin 1841), German architect and painter. A man of wide-ranging interests, Schinkel's architectural vision was inspired by the forms of antiquity. An important early 19th-century figure, his best-known design is the Altest Museum in Berlin, pp. 78, 79, 98.

Schlegel, August Wilhelm von (Hannover 1767 – Bonn

■ Karl Friedrich Schinkel, *Gothic Church on a Rock by the Sea* (detail), 1815, Nationalgalerie, Berlin.

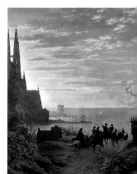

■ Adrian Ludwig Richter, *Sleeping Shepherdess*, 1851, Gemäldegalerie, Dresden.

1845), German writer. His literary works are less important than his theoretical writings, which contain the fundamental principles of Romanticism. Together with his brother Friedrich, he was one of the major exponents of the Romantic movement, pp. 28, 30.

Schubert, Franz Peter (Vienna 1797–1828), Austrian composer. Regarded as one of the foremost Romantic musicians, he is best known for his lieder, intensely lyrical short songs that contain a whole universe made up of changeable impressions and deep revelations, pp. 30, 31, 84.

Sponholz, August, Protestant pastor who was married to Friedrich's sister Catharina Dorothea, p. 9.

Tieck, Ludwig (Berlin 1773–1853), German writer. He was part of a group of Romantic writers in Jena who gathered around the brothers Schlegel.

His creativity found its most successful outlet in stories and fairy tales set in a medieval world, adding some of his own imaginary, fantastical touches, pp. 28, 29, 30.

Thun-Hohenstein von, counts. Purchasers of several of Friedrich's works, including *The Cross in the Mountains*, which was originally destined to decorate the altar of the family chapel in the castle at Tetschen in Bohemia, pp. 40, 47.

Turner, Joseph Mallord William (London 1775–1851), English painter. Influenced by the aesthetic notion of the sublime and the picturesque, his landscapes are intensely poetic, thanks to his careful study of atmospheric effects. In his later works, light dissolves forms in an interpretation of nature that is almost abstract, pp. 86, 87, 105, 121.

Wagener, Berlin consul and collector. He commissioned Friedrich's *Moonrise Over the Sea*, p. 96.

Zhukovsky, Wassily, Russian poet charged with purchasing works of art on behalf of Tsar Nicholas I. He visited Friedrich's studio on several occasions, pp. 92, 93, 126.

■ William Turner, *Willows Beside a Stream*, 1805, Tate Gallery, London.

A DK PUBLISHING BOOK

www.dk.com

TRANSLATOR
Anna Bennett

DESIGN ASSISTANCE
Joanne Mitchell, Rowena Alsey

EDITORS
Caroline Hunt, Louise Candlish

MANAGING EDITOR
Anna Kruger

Series of monographs
edited by Stefano Peccatori and Stefano Zuffi

Text by Raffaella Russo

PICTURE SOURCES
Fotowerkstatt Hamburger Kunsthalle, Hamburg; Bildarchiv Preussischer Kulturbesitz, Berlin;
Sächsische Landesbibliothek – Staats- und Universitätsbibliothek, Dresden;
National Gallery Picture Library, London; Archivio Electa, Milan;
Artothek, Munich; Peggy Guggenheim Collection, Venice.
Elemond Editori Associati wishes to thank all those museums and
photographic libraries who have kindly supplied pictures, and would be pleased
to hear from copyright holders in the event of uncredited picture sources.

Project created in conjunction with
La Biblioteca editrice s.r.l., Milan

First published in the United States in 1999 by DK Publishing Inc.
95 Madison Avenue, New York, New York 10016

Friedrich, Caspar David, 1774–1840.
 Friedrich, Caspar David. -- 1st American ed.
 p. cm. -- (ArtBook)
 Translated from the Italian.
 Includes index.
 ISBN 0-7894-4854-8 (alk. paper)
 1. Friedrich, Caspar David, 1774–1849 Catalogs. 2. Landscape in art Catalogs.
 3. Romanticism in art--Germany Catalogs. I. Title. II. Series: ArtBook
 (Dorling Kindersley Limited)
NA588.F75 A4 1999
759.3--dc21 99-32114
[B] CIP

First published in Great Britain in 1999
by Dorling Kindersley Limited,
9 Henrietta Street, London WC2E 8PS

A CIP catalogue record of this book is available from the British Library.

ISBN 0-7513-0782-3

2 4 6 8 10 9 7 5 3 1

Printed by Elemond s.p.a. at Martellago (Venice)